# WATERFALLS AND GORGES
# OF THE FINGER LAKES

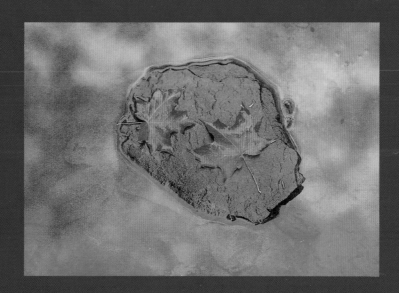

*On the cover:* Grimes Glen

# WATERFALLS AND GORGES OF THE FINGER LAKES

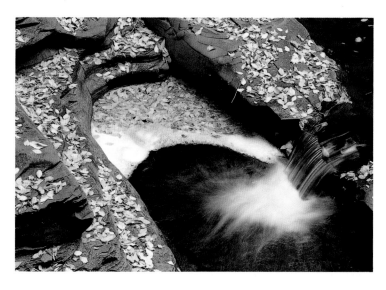

DEREK DOEFFINGER

MCBOOKS PRESS  ITHACA, NEW YORK

Book and cover design: Paperwork

Library of Congress Cataloging-in-Publication Data

Doeffinger, Derek.
    Waterfalls and gorges of the Finger Lakes / Derek Doeffinger.
        p.        cm.
    Includes bibliographical references and index..
    ISBN 0-935526-24-2
      1. Waterfalls—New York (State)—Finger Lakes Region.  2. Gorges—
New York (State)—Finger Lakes Region.  I. Title.
    GB1425.N4D64  1996
    551.48'4'097478—dc20                98-8826
                                     CIP

This book is distributed to the book trade by Login Trade, a division of LPC Group, 1436 West Randolph Street, Chicago, IL 60607. Additional copies of this book may be ordered from any bookstore or directly from McBooks Press, 120 West State Street, Ithaca, NY 14850. Please include $3.00 postage and handling with mail orders. New York State residents must add 8% sales tax. All McBooks Press publications can also be ordered by calling toll-free at 1-888-BOOKS11 (1-888-266-5711). Visit our web site at: www.McBooks.com.

Printed in Hong Kong

9 8 7 6 5 4 3 2

---

A number of the sites pictured in this book are on private property. Please inquire before visiting and respect the rights and wishes of property owners.

---

# ACKNOWLEDGMENTS

THANKS to McBooks Press publisher Alex Skutt for taking on this book; to Sandy List for her seamless and meticulous editing; and to George McIntosh of the Rochester Museum and Science Center for his technical review (any remaining errors are all mine).

*This book is dedicated to my daughter*

# CONTENTS

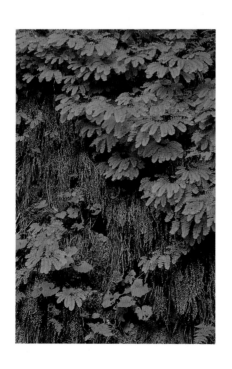

# FOREWORD

"ITHACA IS GORGES," proclaims the bumper sticker displayed both locally and throughout the world. And so it is. As a catch phrase, that bumper sticker suggests something of the remarkable beauty of the Finger Lakes. Lying in a gently rolling agricultural landscape marked by level upland pastures and precipitous gorges, the narrow lakes extend like the fingers of two outstretched hands. It is the presence of these lake basins, running roughly north-south, that accounts for the waterfalls and gorges which add such distinctive beauty to the area. For this is a land of contrasts, of unexpected variety within an encompassing uniformity, of violent cataract within a landscape of pastoral placidity. The contrast can be as great as that between the deep snows of an upstate New York winter and the embracing softness of an Appalachian spring, making this a country marked by a strange combination of awesome grandeur, subtle charm and striking beauty.

Indian legend has it that the Finger Lakes were gouged out from the land by the claws of a giant bear. Other tales have them as the handiwork of gigantic humans, still others as the handprint of God. The contemporary scientific explanation, though more prosaic, is no less beautiful, nor is it without mystery.

In this book, author and photographer Derek Doeffinger traces the geological story with vivid simplicity, scientific economy and appealing directness, capturing in just a few pages the great sweep of events over long eons of time that contributed to the formation of this remarkable countryside. The erosion of the deep, cold, narrow lakes, flanked with steep gorges incised into heavily jointed, gently dipping sedimentary rocks, has produced cascading waterfalls, swirling plunge pools and narrow canyons that are sunless for most of the day. In both words and pictures, Mr. Doeffinger has captured the origin and history of this remarkable landscape with an immediacy that is compelling.

But our author does more than this, for his photographs are gems in their own right, exquisite in their refinement and sensibility, charting the changing moods of the seasons and the varying scales of erosional activity. Here a mighty waterfall surges at its full strength, there a small icicle-covered cascade glitters in the weak sunshine of a winter day.

Embracing all this is the author's own sense of enthusiasm, his anticipation of the unexpected discovery around each bend of a gorge, the thrill of a new glimpse of a rushing cascade above the next rock ledge.

This is more than just a coffee table book of striking photographs. It is more than a popular scientific explanation, though we are given that with persuasive accuracy and charm. It is an invitation to walk, to climb, to scramble, to gaze, to contemplate, to ponder, to wonder, to understand. Two millennia ago, Job was told, "Speak to the earth and it shall teach thee." This book invites us to share a conversation, not with the planet at large, but rather a quiet and intimate conversation in the filtered sunshine of the magical landscape of the Finger Lakes.

E.B. White once wrote to his friend and mentor, Bristow Adams, at Cornell, "There is something about those gentle hills and cradled valleys that never stops working in the blood." This book illustrates why that enchantment continues so powerfully today.

FRANK H.T. RHODES,
President Emeritus, Cornell University
Professor of Geology and Mineralogy
Ithaca, February 1996

# INTRODUCTION

HERE ARE SOME of the things I have found among the Finger Lakes waterfalls:

A sliver of adventure in a landscape otherwise roped off to promise civilians safety and bureaucrats peace of mind. A hint of danger, the natural kind, and a brief opportunity for self-reliance. Solitude. The simple pleasure of feeling a 60-foot waterfall pounding onto your back with a force that's frightening and a relief that's indescribable. Discovery—flakes of shale raining from cliff rims like confetti from skyscrapers, a pinwheel of yellow autumn leaves turning round and round in the eddy of a stream. Death—three deer, their bodies broken after plunging off a cliff. Comfort—the pleasure of a pair of dry socks to put on feet frozen after breaking through a lid of ice. Anticipation—of what's around the next bend in the creek or what waits to be discovered on the next trip. Wonder at the power of a stream an inch deep surging over slime-lubricated rock and somehow, unbelievably, pushing you closer and closer to the brink of a small waterfall. All of these too much to resist for a person confined to a ten-by-ten corporate pen where the air is recirculated, the babble incessant, and the blue sky but a hint in a distant window.

My obsession with waterfalls began with another obsession—photography. I took pictures like some people chain-smoke. A camera was always in my hands, and I was always pressing the shutter button. I don't think I'll psychoanalyze why. My obsession with photography led to a job with Kodak as a writer/photographer for how-to photo books. I always needed new pictures, new subjects for the books. Eventually, the need for pictures led me to a waterfall. And then the need for waterfalls led me to other waterfalls.

At first I went to those in state parks. They were plentiful. They were accessible. They were often spectacular. But they were well populated and tightly regulated, condemning me to be just another tourist. Trails, often paved with stone, led me by the nose to scenic overlooks. Fences and signs prohibited any exploration—too dangerous, thought the state.

One day, while driving along a back road I passed over a stream and spotted a dirt parking area. On a whim, I pulled over. A short, narrow path led from the parking area to the stream. I followed it. After a few hundred yards, I came to a five-foot waterfall. I climbed it and followed the stream. I came to a 20-foot cascading waterfall. I climbed it and followed the stream. I came to a 60-foot cascading waterfall and stopped. It was getting dark.

The next day I bought a book of detailed maps—the DeLorme *New York State Atlas & Gazetteer.* I examined the maps of the Finger Lakes area, studying the numerous streams and the contour lines around them which indicated the steepness of the topography. Only a few streams had the hash mark representing a waterfall. But I was undaunted. I knew what the narrowly spaced contour lines meant and, with the lines crowding in on stream after stream, I knew there would be plenty for me to do in the next few years.

After a few trips, I found out a map wasn't even necessary. My strategy was simple: Drive along one of the roads paralleling a Finger Lake until I passed over a stream. Stop and explore it. Inevitably, the stream held several falls. Like dandelions, they were everywhere. And, again like dandelions, nobody seemed to pick them. Nobody haunted them, nobody explored them. I was alone in these gorges. I had no idea what awaited me. There was no literature about them, no signs marking trails, no maps indicating what to look for. They were mine to explore.

That there were so many was bad enough, that I had to get to know each one was worse. This was the

photographer in me. I couldn't simply visit one, take a few pictures, and move on to the next. That wouldn't do, not for a dedicated landscape photographer. Ansel Adams established the *modus operandi*. He would camp out at a location for weeks just to get the right lighting for a good picture. Damn him. If I wanted a good picture, it could hardly be considered hardship to make a 90-minute drive when the occasion seemed right.

So, a few weeks later, after several days of rain, I went back to the falls I had visited before, knowing they would be roaring. Two months after that, when autumn had set in and the leaves were aflame, I went back. Then when the leaves fell, giving the gorge yet another appearance, I went back. Then snow fell. Then the snow melted. Then the spring flowers blossomed. Then the leaves budded. I went back and back and back, visiting the same waterfalls over and again, and picking up one or two new ones, expanding my range. One trip turned into ten and ten into a hundred, and one year became two, then three, and then—

Each time, the falls looked different, even if I went back a year later on the same date. What most affected the appearance of a spot was the season. Not surprisingly, the winter gorge and the summer gorge differed most dramatically. But not because of snow. Even without snow or ice, they were completely different. It was the light and the lack of leaves. Surprisingly, though the days of winter are shorter and the sun lower in the sky, the winter gorge is brighter.

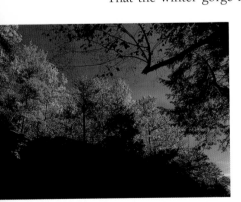

That the winter gorge is brighter is confirmed by the camera's meter, its light-measuring device. In summer, in some narrow gorges covered by trees, a picture might require a two-second exposure. In the same spot in winter, it needed only a quarter or an eighth of a second, meaning there was eight to sixteen times more light in that gorge in the winter than in summer.

Why? Because the millions of miniature shades in the form of leaves had fallen and light from the sky streamed in. With the leaves gone, not only light was gained but distance. Suddenly my world expanded. I could see past the first few trees of the forest into its

depths. Hills sloped in the distance and clouds drifted by branches. A sense of claustrophobia had been lifted. In winter, the gorges, unlike so many other landscapes, become bright, even cheerful.

Until the snow and ice settle in. The transformation is dramatic in both sight and sound, like a teenager's clothes-strewn, hard-rock–throbbing room magically turned into a sterile computer "clean room" where the rustle of clothes seems deafening and a cookie crumb is a mess prompting disciplinary action. A lid of ice covering the stream muffles the incessant burble of water. A blanket of snow hides rocks and logs and stumps and leaves and all the other clutter under a uniform of white. The appeal of the winter gorge is often subtle, apparent only to the discerning eye.

But the large free-falling winter waterfalls are a sight to see. They form thick columns of ice that tempt climbers to pry their way up. They form large, hollow ice domes at the base, big enough for a car or even a house to fit inside. And the spray from the waterfalls coats the cliffs like the hoarfrost on an Arctic explorer's beard. Icicles of all sizes dangle everywhere. Some places dazzle with thousands of foot-long icicles clinging to cliffs from top to bottom. Others offer quality and size instead of numbers. A few huge icicles, ten to twenty feet long, hang precariously from the upper heights, sometimes in clusters of two or three, threatening like a giant pitchfork and never out of your mind as you pass beneath them.

Still, the obvious season for waterfalls is late spring when the air is warm and the water high; waterfalls buck through the air with a sense of unbridled power and wildflowers tremble in warm breezes wafting through the gorges.

If you have the urge to explore, I recommend that you start with the obvious, the quintessential spring waterfall tumbling down rock, leaping off a cliff face. Then wade through summer's cool, gentle cascades. Come back in autumn, when the drive through the rippling color of Finger Lakes hills will send your spirit soaring, and red and yellow leaves spiraling through the currents. And finally, in the dead of winter, when the highs are ten degrees Fahrenheit and the midday sun glows like a dying ember, come back on the deserted roads and through the empty towns to Taughannock Falls. Hike the gorge trail and complete your contemplation of the gorges.

# A GEOLOGY PRIMER

To START WITH the glaciers plowing through river valleys would be too near in time. To start with swirling galactic gases cooling and condensing into a planet would be too far. Beginning with the events and forces that formed the oldest rocks being broken down by the waterfalls is just about right. These are the rocks still visible when you hike the gorges.

Their time started in a faraway land long ago. Really. The place was near the equator, roughly where northern Brazil is today. The time was some 450 million years ago—long before humans of any kind uttered a word, sparked the first fire or planted the first seed. Indeed, it was a time before there were humans, even before there was a proper seed.

Four hundred and fifty million years is a long time, even for a planet ten times older. As we shall see, a lot can happen in such a span, both to the land and to the life inhabiting it. Back then, the earth nurtured no flowering plants, no roses or forget-me-nots, no maples or oaks or any other kind of tree; there were no squirrels, horses, mammoths, dinosaurs. No sharks, no alligators, no birds. Life on land had not yet developed legs or roots.

What was there? Water. Oceans of it, and within the oceans, life had begun to swarm in a variety of forms. Primitive fish glided through the depths. Starfish edged into the shallows. Corals flourished and spread through the warm seas. Clams buried themselves in the sands. A host of sea creatures—trilobites, brachiopods, crinoids and bryozoans—lived their lives and left their marks for us to study in fossilized remains. These remains provide clues (although none can reveal the whole story) to the earth's changes.

## Drift and collision

The arrangement of land masses 450 million years ago resembled nothing we know today. And though I will refer to some of these ancient lands by their modern names, in truth, there was no North America, no Asia, no Africa or South America—at least not as we know them.

But there was land. As it is today, the land back then was moving and changing. And these movements were documented. In the past century, scientists have learned that the land itself recorded what it was up to, where it was going and where it had been. In the past 40 years, they have learned how to read these records with increasing accuracy. Discovered in bits and pieces, the story fits together with eruptions of drama, then settles in for long stretches of subtle, steady change.

It's the story of continental drift and plate tectonics. Of lands made and unmade. Of oceans filled and emptied, mountains raised and lowered, volcanoes exploding and volcanoes stilled. And, unlike the mind-boggling, incomprehensible distances and foreign equations of light years and $E=mc^2$, this is a story whose basic workings make sense.

Except for the time. Dealing with the enormous amounts of time, believing the earth is really so old—it's not easy. To a mouse, a year is a lifetime; to a person, one hundred years is an exceptional lifetime. But a hundred million years only gets a continent to preschool. Comprehending a hundred million years is as difficult as comprehending a light year. In fact, it's impossible to understand it in an everyday sense. Minutes, hours, days, years are our reality. Millions of years are too much.

So the time to begin the story is when we, as

students of the world, first begin to get a sense of world geography and a feel for the nature of time. For me, understanding the beginning of the waterfalls and gorges of the Finger Lakes started in the ninth grade, 1964. Back then my attention wandered between the buxom Miss Adner and her pointer sweeping across a map from continent to continent. Like many another school kid, when my eyes landed on the right place, I noticed the obvious: that the bulge of South America seemed to fit neatly into the recess of Africa—a continental jigsaw puzzle.

But even as Miss Adner said no, they never were joined, scientists were busily proving that yes, they had been, and that Alfred Wegener's theories of colliding continents, rejected in the early 1900s, did indeed have merit, even if he couldn't explain how it all happened.

## Mountains rise, mountains fall

So let's begin again, some 450 million years ago. The critical continental jigsaw pieces in our story are on the move, with dramatic consequences ahead. They are sliding toward each other, roughly in the region where Brazil is today. Hot molten rock slowly rising from the earth's interior drives the continents across the earth's surface. This time it shoves the eastern edge of North America against a string of volcanic islands, similar in structure to the Hawaiian islands of today. Like a head-on car crash, though in infinitely slow motion, the result is a massive crumpling and buckling—in this case, of land. This creeping collision lasted millions of years and welded some of the volcanic islands to the eastern coast, where they sporadically erupted. When land crumples and buckles, mountains form. The collision lifted up the land, millimeter by millimeter, into a north-south chain, named by geologists the Taconic Mountains.

For this event, the state of New York was adjacent to or part of a section of the front bumper on the continental taxi. As with all taxis, collisions were a fact of life—there would be two more.

The Taconic Mountains stretched a thousand miles from north to south.

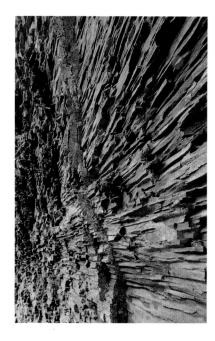

Their height is uncertain. They were tall, perhaps as high as the Rockies, possibly even the Himalayas. Today, except for a few minor outcroppings of rock in New England, they are gone. Imagine the Himalayas, or the Alps, or the Rockies gone. Almost nothing left behind. It doesn't seem possible. And that the Taconic Mountains were erased grain by grain seems even more impossible. But it happened and, elsewhere, it's happening still.

Even while the Taconics were being pushed ever higher into the sky, rain, drop by drop, and snow, giving way to spring torrents, was tearing them down. For millions of years, the mountains continued to rise faster than they were being eroded. They rose a fraction of an inch to several inches a year and, in the same period, were eroded only a millimeter or two. The net effect was higher mountains.

But eventually they stopped rising. The internal bubble of molten material that powered the collision had cooled or subsided or redirected its energy. The millimeters of erosion began to add up. The mountains started to dwindle.

This happened ever so slowly. In a hundred years, raindrops crashing onto mountain tops, knocking bits off and sweeping them away grain by grain, may reduce a mountain's height by four inches (at a millimeter each year). In a thousand years, by 40 inches and in a million years, by 40,000 inches. In ten million years, erosion would chip off 400,000 inches or 33,000 feet, enough to flatten even the highest of mountains.

That's just what happened to the Taconics. They were flattened a raindrop at a time. Though this picture may be simplistic (erosion doesn't occur at so steady a rate for such a long time), it does show that, given enough time, mountains can be torn down bit by bit. And time is what land has. Eons upon eons of time.

Much of the Taconic Mountain material was carried westward by streams and rivers to form a large delta of sediment, not unlike the delta at the mouth of today's Mississippi River. This formation is referred to as the Queenston Delta, and its

sediments are visible as the lowest layers of rock in the Genesee River gorge of Rochester. This is the oldest layer of rock visible in the region.

As the accumulating sediments grew into layers of shale and silt hundreds of feet thick, ancestral sharks began prowling nearby seas, and the forerunners of frogs and salamanders gasped their first breaths under the fronds of palm-like ferns swaying in the sky. As the mountains continued to be ground down and swept away, other continents were on the move. Forces inside the earth had pushed Africa near the South Pole, where it endured an ice age. What we now call the Sahara Desert felt glaciers grinding across its skin, scarring it and gouging grooves which can still be found in the desert bedrock.

But the climate in that ancient New York was warm and wet. An accumulating load of sediment enlarged the breadth of the delta even as its altitude diminished. Internal forces deep in the earth were the cause. The delta sank below sea level. Ocean waters ebbed in. They formed a large shallow inland sea. At times, portions of the sea would evaporate, leaving behind large deposits of salt. Today, these form some of the largest salt mines in the world.

The growing delta and sea above it compressed the muddy sediments from the Taconic Mountains into rock. Shales, silt stones and sandstones formed layers of rock a thousand or more feet thick. Similar layers, plus limestone, would form in the future.

## The young continent changes

One hundred fifty million years later, the Taconic Mountains were gone, the North American continent had moved several hundred miles northward across the globe, and a new collision was brewing—the second of three important to our story.

The North American continent still resided in the tropics. Off its eastern shore lay the small continent scientists call Avalon. Some 380 million years ago it slid into eastern North America with results similar to the previous collision. A chain of mountains, the Acadians, rose over millions of years. Then, these mountains too were eroded away over millions of years.

Their sediments were carried to the west, into the Catskills region, and further westward into what was to become the Finger Lakes territory, and even

westward beyond that. Most of the sediments spilled into shallow seas, whose shorelines fluctuated. At the sea's greatest span, it stretched from eastern New York to western Ohio. Sometimes the shallow seas held stable over thousands of years. When they did, the carcasses of millions of tiny shelled creatures accumulated into layers of limestone, which hold up several of the Finger Lakes' more spectacular waterfalls. Millions of years later, internal forces pushed the sea floor up to become land. In New York, the layer of sediments eroded from the Acadians is called the Catskill Delta because of its prominence in the Catskill area.

These were not the last sediments to bury the Finger Lakes region and become rock beneath it. But they were the last critical to our story, for this is the rock we see in the gorges today, rock roughly 370 million years old.

Three hundred and twenty-five million years ago, the final collision for North America was imminent. Large-scale trees and seed ferns thrived in the tropical climate in proportions vast enough to spawn the huge coal fields of eastern North America. Humans were not even a glimmer on the horizon.

The final collision was a grand one. It brought all the modern continents together into one giant land mass called Pangea ("All Land"). Coastal New York and New England formed the continental bumper as they slowly sideswiped northwestern Africa. When the collision ended, it would have taken just a few hours to drive to Morocco from eastern New York. The top speed reached by the two colliding continents was about a hundred-millionth of a mile per hour—or about twice as fast as your fingernails grow.

But, as we now know, given a few million years, a slow-motion collision can wreak havoc. We also know the result—a new chain of mountains, in this case, mountains that are still with us today. They are the Appalachians.

Like the mountain chains before them, they have been eroded and are being eroded. They are no longer rising and, today, they are but half, or maybe a third, of their original height. Although much of the eroded material was carried east to the sea, a large amount was also swept westward. Over the next hundred million years, these sediments poured into shallow seas covering the as-yet-to-be Finger Lakes region, and territory

further to the west. Here, they accumulated and hardened to become shale, sandstones and silt stones like those in today's gorges.

But they were only like the rocks there today. They are not those rocks. Although sediments eroded from the Appalachians were the last deposited in the region, they were quickly eroded away. What was left near the surface were sediments from the Acadian mountains, sediments deposited in the Catskill Delta some 55 million years before.

And so the preparations were in place. Let's speed up the film and watch as infinitely slow movements go into action. The continental players end their embrace. North America heads northwestward, away from Africa, a few inches a year (as it still does to this day). The Atlantic Ocean is being born and growing steadily as Africa and North America move apart. Ocean currents move through the new gap now separating the continents. The currents will redistribute the earth's heat, and change the world climate.

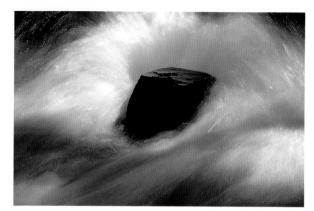

Everywhere, new life forms are evolving. Over the next 50 million years, flowering trees and plants will throw open their blossoms. Birds will flutter and soar through the skies for the first time. Mammals will dash across fields and burrow in forests. Dinosaurs will dominate for millions of years and then die off, making way for mammals to proliferate and become the next prevailing class of large animals. Humans? Earth knows nothing of them yet.

At last the requisite materials for sculpting the Finger Lakes were all assembled. It took well over 400 million years to build and scrape away the better part of three mountain chains, to move the North American continent from equatorial zones to more northern latitudes approximately where we are now, but it arrived in a much warmer climate, more like South Carolina.

First, the sculpting forces needed a rough shape to work on. The land rose. Sea levels dwindled; water from the shallow seas trickled back to the growing Atlantic Ocean. Dry land emerged where, for millions of years, a shallow sea had rolled. Streams and rivers flowed over the land to form southward-draining watersheds and carve rolling hills and valleys as they wound toward the sea.

## The power of ice

Then, the ice. Over 20,000-year periods, the amount of heat reaching the earth from the sun increased and decreased. The difference was slight, but its effects, given the right conditions, were enormous. The differences in heat corresponded to changes in the tilt of the earth's axis and its orbit about the sun. Although these changes reduced the heat reaching the earth, the reduction didn't always significantly reduce the earth's temperature. That depended on how well the heat was distributed. And heat distribution depended in large part on the position of the continents, whether they blocked ocean currents carrying heat from the warm equator to the cold poles or provided channels for the currents.

When the supercontinent Pangea broke up, heat distribution became more localized. Continents blocked the broad flow of warm equatorial waters to the poles. Polar ice caps expanded. The bright white of the expanding ice caps reflected sunlight back into space, further reducing the heat levels and further expanding the ice caps.

And, gradually, the climate changed. Some two million years ago long, cold, snowy winters struck the northern hemisphere; short, cool summers followed. The pattern established itself: hundreds of years of snowy winters followed by cool summers. An ice age was developing.

Except in the most northern latitudes, the early effects would have been virtually unnoticeable. Over the centuries the increasing cold may have pushed plants and their accompanying animals—in fact, whole ecosystems—a few hundred miles south. But basically things looked the same.

In the northern latitudes, though, change was underway. The snow was accumulating in huge masses. It wasn't melting back in the summer. And, as the masses of snow grew, they spread out. Deep down, under enormous pressure from the weight above, snow

turned into ice. Under this great burden, the ice became plastic and began to flow. A glacier was born. Then more glaciers. They merged. They became a giant sheet of ice that headed southward. The ice moved slowly at first, maybe a quarter of a mile a year, then faster, as much as a mile a year. At their greatest reach, the glaciers smothered the northern hemisphere and covered a third of the earth. So much water was frozen into ice that the seas were lowered over 300 feet.

With the continuing climate of heavy winters and cool summers, the snows built higher and higher, pushing the mega-glacier further and further south. It was like a giant bulldozer, plowing across the landscape. Although its leading edge would follow the land's natural contours, the main part of the glacier was deep and unforgiving.

It ripped house-size boulders from the ground and carried them ten, twenty, even a hundred miles distant. It tore off the north-facing ends of mountains. It picked up everything—soil, pebbles, rocks, boulders; the bottom worked like a giant piece of sandpaper, gouging, scraping, grinding all it passed over. The ice moved on, absorbing much of the remains and, eventually, dropping everything. It changed the landscape dramatically and quickly.

For some 90,000 years, glaciers headed southward into the northern United States. Then the cycle of the earth's orbit and tilt changed so that the northern hemisphere received more sunlight. The climate gradually shifted. Summers started to last longer, grow warmer. The glacier retreated back to the north, dropping vast amounts of sand and gravel as it melted. And for maybe 15,000 years, a more moderate climate prevailed. A cycle of ice ages had been established.

Over a period of about two million years, glaciers arose, spread and retreated, perhaps fifteen times, maybe more. One hundred thousand years of glaciers. Ten to fifteen thousand years without. At least four times, and perhaps more, they reached into New York. Why the uncertainty? Because, like a giant broom, each succeeding glacier swept away evidence of the one before.

But evidence from the next-to-last glacier remains. Along with the very last glacier, it shaped the Finger Lakes we know today. The final one filled in the details. When the next-to-last glacier plowed its way through New York, it encountered shallow river valleys where the Fingers Lakes now lie. The land funneled the enormous mass of ice into these valleys, concentrating the force and power of the glaciers. They gouged out the valleys, deepened them by several hundred feet, and turned hills into mountains.

## The power of water

When that next-to-last glacier retreated, the true sculpting of present-day waterfalls and gorges began. All the key parts and forces were in place. The raw materials of shale, sandstone and limestone had been shaped into rough hills and mountains. Plentiful rain and snow fell, and formed streams and creeks that tumbled down hillsides.

As they ran, they picked up sand and gravel and rocks and, with the torrents formed during spring snow-melt, even whole boulders. They became an abrasive slurry that cut through the soft shale. The streams twisted and turned, as the softest rock yielded first to the water and determined the path the water would follow. Year after year of grinding carved out narrow winding corridors in the mountains. Most of the year's work happened in the spring when the melting snows swelled the streams till they raged down the mountains.

When the slurry encountered a layer of harder limestone or sandstone, it ran over it with little effect. But if softer material lay immediately beneath, that was cut away, and a leaping waterfall was born and enlarged over the years. If the underlying shale or sandstone was sufficiently more durable than that just below it, a cascading waterfall formed. The water and its slurry of rock and pebbles ground on a softer stream bed until it retreated to the edge of the harder layer. Water seeped into the softer rock and then, in winter, it froze and pushed the rock out, eventually creating an area behind the falls.

The power of water, gravity and time could not be denied. Thousands of years of spring surges ripping down a mountain carved out many gorges, some with cliffs hundreds of feet high. Numerous smaller ones snaked their ways down hillsides. But the work done in the wake of the next-to-last ice sheet—the Illinoian glacier—would be modified by the very last one. Brought on some 100,000 years ago, when orbital and climatic conditions again reinforced each other and led to increasingly longer, colder, snowier winters

and shorter, cooler summers, that final ice mass was born. It's come to be known as the Wisconsin glacier.

Slowly it edged into New York, into the same areas occupied by the Illinoian glacier that preceded it. It was big and powerful and deep. If you placed one Twin Tower from New York City at the bottom of Seneca Lake and stacked the other Twin Tower on it and then, on top, balanced the Empire State Building (with King Kong still clinging to it), the stack would nearly be submerged in the ice. Only King Kong's head might protrude. At its deepest in the Finger Lakes, the glacier was more than 3,000 feet thick. It covered nearly all of New York State.

## Lakes and hanging valleys

Like the preceding glacier, it bulldozed its way southward. It further deepened the river valleys, which lay in the hollows now occupied by the Finger Lakes. Like its predecessor, it tore off or wore down the northern ends of some mountains. All this material was carried southward, then dropped to form a huge earthen dam, or "moraine," running from east to west. Located south of where Ithaca is today, this dam ultimately blocked the south-flowing rivers to form the Finger Lakes, many of which now drain northward.

But what's more important to the formation of the Central New York waterfalls is this: as the glacier headed south, it cut off midway the beds of many mountainside tributaries flowing into the valleys. In a sense, it created instant waterfalls, though they wouldn't appear until the glacier withdrew and uncovered them. Before the glacier, the streams tumbled down mountainsides; after it passed, surviving streams tumbled down mountainsides and then fell through the air, because the glacier had cut away parts of their mountain. Waterfalls formed this way spill out of outlets called "hanging valleys." Taughannock Falls, just north of Ithaca and the highest waterfall in New York State, flows from such a hanging valley.

The final glacier melted backwards and withdrew from New York 13,000 years ago. As the ice melted, it left large deposits of gravel, sand and rocks. Some of this material dropped into existing gorges, some was deposited right on the land, the source of the many gravel pits in the region today. As it went, taking thousands of years to go, the glacier's meltwaters and temporary ice dams created many large temporary lakes, including Lake Iroquois, which lapped at shores miles beyond the boundaries of its descendant, Lake Ontario. Many of these lakes still exist, though they are smaller than when they were fed by torrents from a melting glacier.

When the last glacier withdrew, the land was again exposed to the sculpting touch of water, snow and ice. For the past 10,000 years, these elements have been redesigning the land, creating new waterfalls, excavating gorges, demolishing cliffs. You can see the results in this book and, for yourself, outside. Any drive along southern Finger Lakes roads will carry you past a waterfall. Any exploration along a stream passing under the road will carry you to a waterfall. As you walk past the cliffs, examine them. They are the leftovers of ancient mountain ranges and seabeds, hundreds of millions of years old.

## Our own ice age

As you sit under a waterfall on a hot summer day, know this: as unlikely as it may seem, you are in an ice age. Yet others fear the earth is warming. Climatologists warn that human activity over the past hundred years has started a global warming.

They could be right. If so, the short-term consequences for humanity could be dire. But on a geological time scale, the warming may be but a blip. For the ice age we are in has lasted two million years and for the past 1,999,900 of them, there have been no global climatologists. The rule of glaciers in northern climates has lasted one hundred thousand years, with the interval between their advance and retreat seldom more than 15,000 years.

If the cycle holds true, as it has some 20 times before, then in a few thousand years, immense glaciers from the north will once again slip southward and bury the land in ice. If global warming prevails, existing glaciers and polar caps will melt back, flooding coastal areas and changing climates around the world dramatically. Whatever happens, the events will be recorded in the rocks.

# THE PHOTOGRAPHS

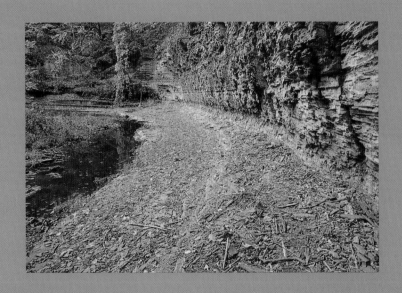

# |GREAT GULLY

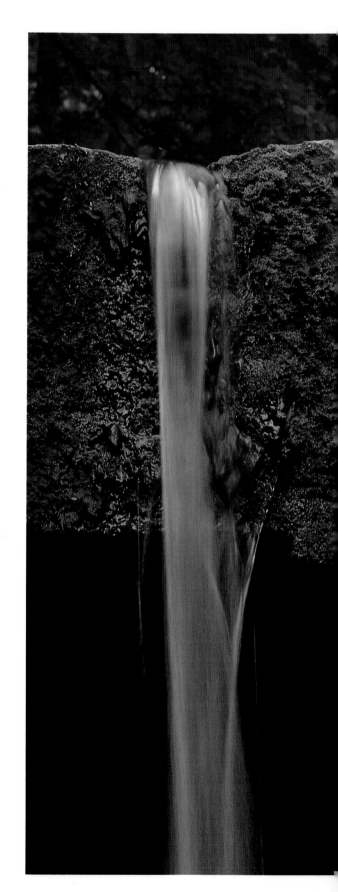

In summer, the 40-foot wide stream in Great Gully dwindles to three ribbons of water falling over a shelf of limestone. Among the hardest of rocks in the gorges, this limestone has barely yielded to the water. Despite hundreds of years' wear, it shows only shallow grooves that channel the water into three streamlets.

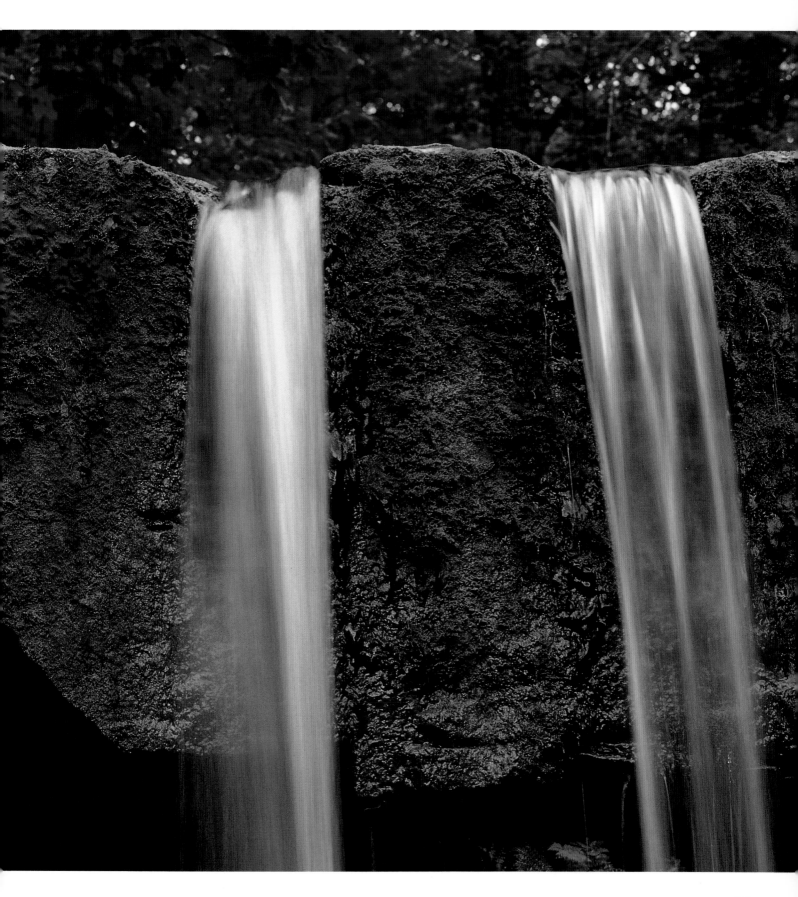

# GREAT GULLY

The low water of summer has exposed the limestone streambed in the Great Gully. Limestone is tough and does not yield readily to physical erosion. But its chemical nature is such that it dissolves in acidic conditions. While other gorges are torn apart by floods and chipped away by expanding ice, those with limestone bedrocks quietly yield to the mighty puddle.

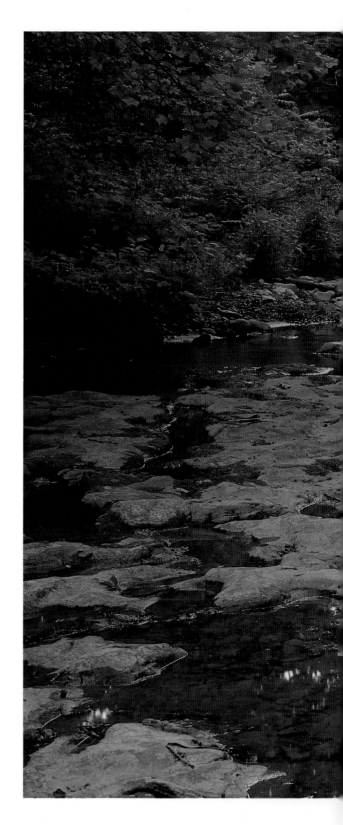

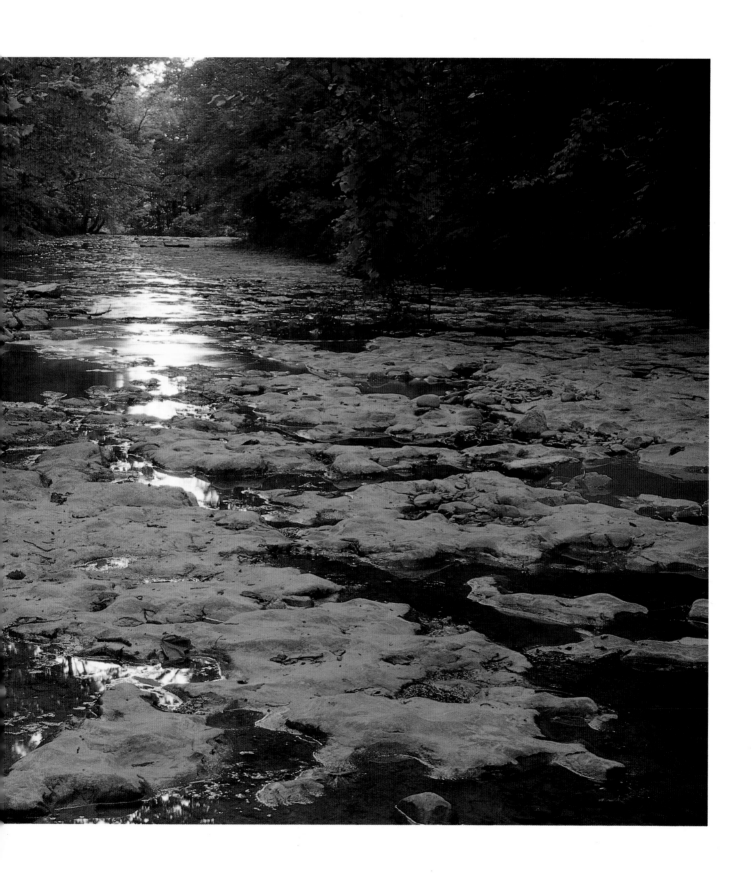

# TANNERY CREEK FALLS

About 20 feet high, this free-falling stretch along Tannery Creek drops and immediately spills into a 50-foot cascading waterfall. Here, as in most gorges, the power of a waterfall constantly tearing at the rocks leads to frequent and obvious change. Change is the theme of all gorges.

Suburbanites and city dwellers tend to think of the natural landscape as fixed and unchanging. A hill on the way to the store is expected to look the same day after day. The changes are too subtle, and those un-attuned don't notice them.

We see change only when bulldozers appear, to re-contour the land for a new subdivision of houses or a mall. But in the wilds of a gorge, change is noticeable, even to those who make repeat visits separated merely by months.

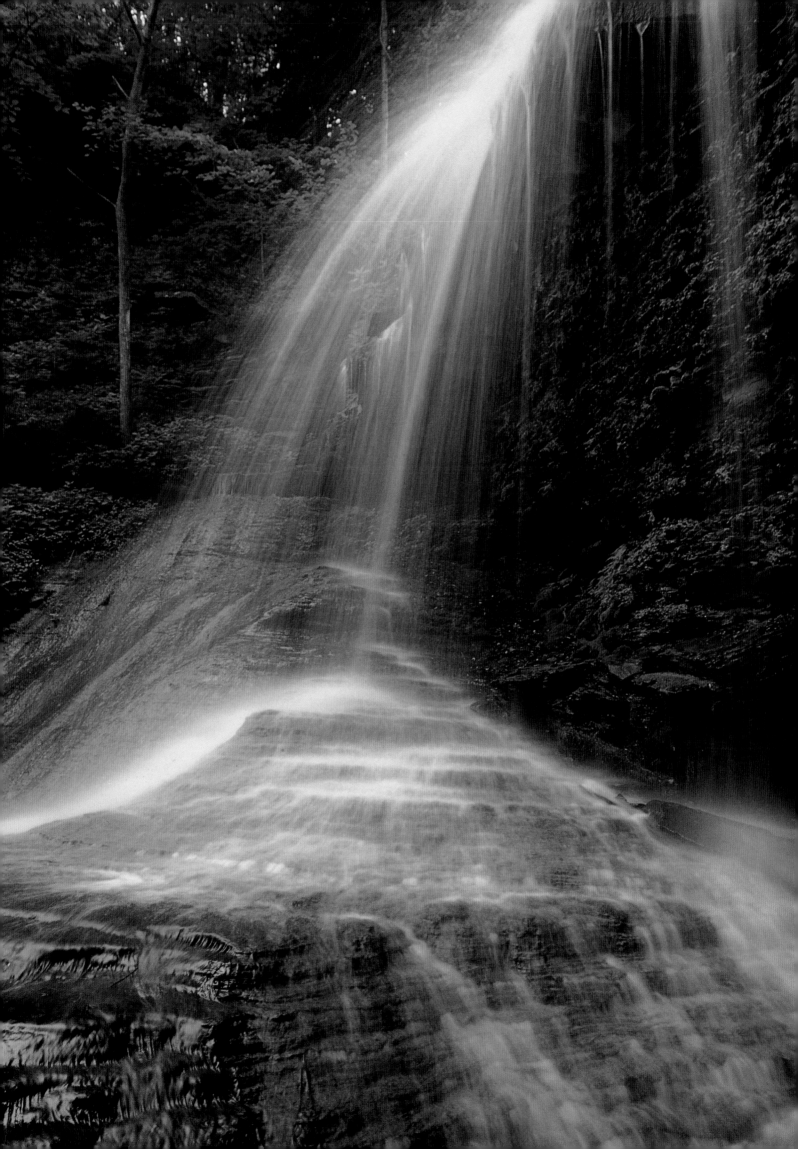

# CARPENTER FALLS

Perhaps the prettiest of the free-falling waterfalls, 90-foot Carpenter Falls clearly displays the geology which dictates its existence. The shelf of rock it spills over is limestone. Limestone is considerably more durable than the shale underlying it. Water and ice eroded the underlying shale, creating a large recess behind the falls. Eventually the recess will become so great that the overhead shelf of limestone will break under its own weight and crash to the pool below, where several blocks from a previous collapse now lie.

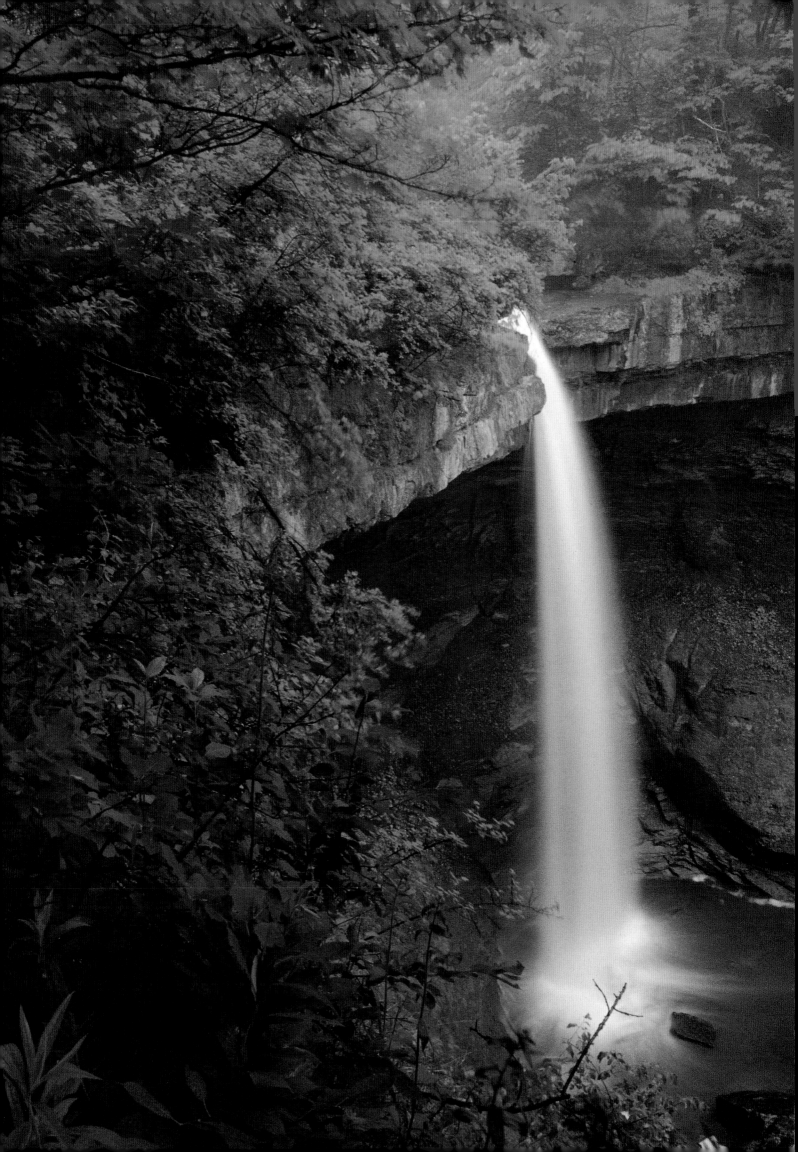

# EGGLESTON GLEN

What is most remarkable about this glen are the large boulders in the stream. In most gorges, the streambeds are either bare or jammed with smaller rocks. Sometimes, they're so plentiful that it's a challenge to maintain your balance as you step from one wobbling rock to the next.

These large boulders are called erratics. The glacier carried them here. The two in this picture are the size of a VW Beetle. As the glacier swept over the land, it picked up nearly everything in its path—soil, pebbles, trees, rocks and boulders, even ones much bigger than these. By studying such boulders to determine their point of origin and distribution, scientists can often retrace the glacier's path, almost like following a trail of bread crumbs.

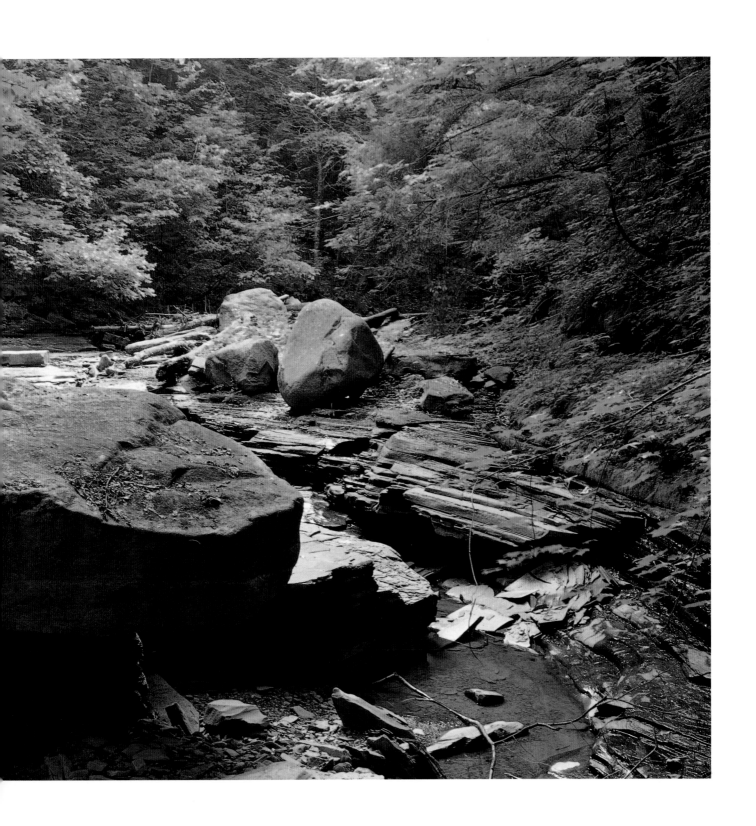

# STONY BROOK

A stone walkway borders the stream running through the gorge and an elegant stone bridge arches over the stream in the lower part of Stony Brook State Park. All such features were built by the Works Progress Administration during the Great Depression, including two natural-looking (but man-made) swimming pools incorporated into the stream.

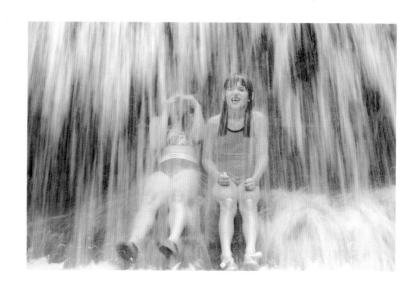

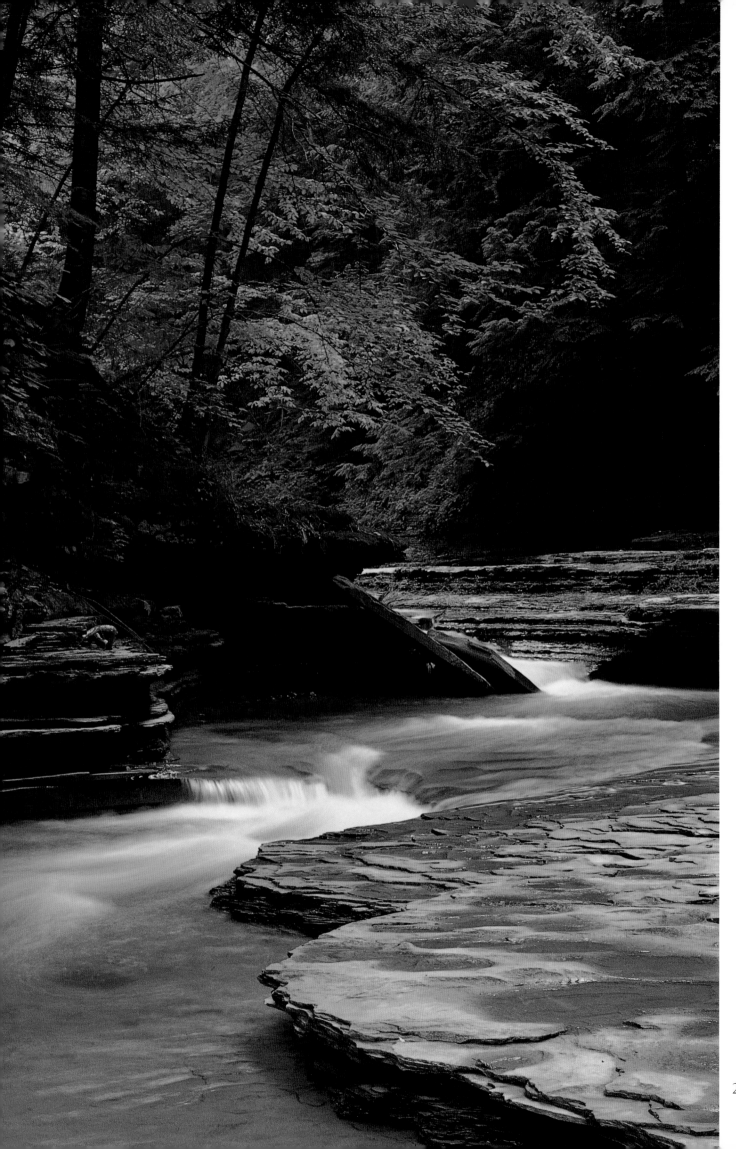

# STONY BROOK

Sitting in a waterfall or sitting by one—each provides pleasant but different sensations. If you take a seat in this gentle waterfall in Stony Brook State Park, hundreds of streamlets flutter across your body like ribbons.

Charged with oxygen, the water teems with bubbles that burst and tickle when they hit your skin.

Should you decide to sit by a waterfall, you'll be refreshed by a constant breeze fanned out by the falling water and carrying a cool mist. You'll hear the relaxing whoosh of water and watch the ever-shifting threads that make up the larger fabric of the falls.

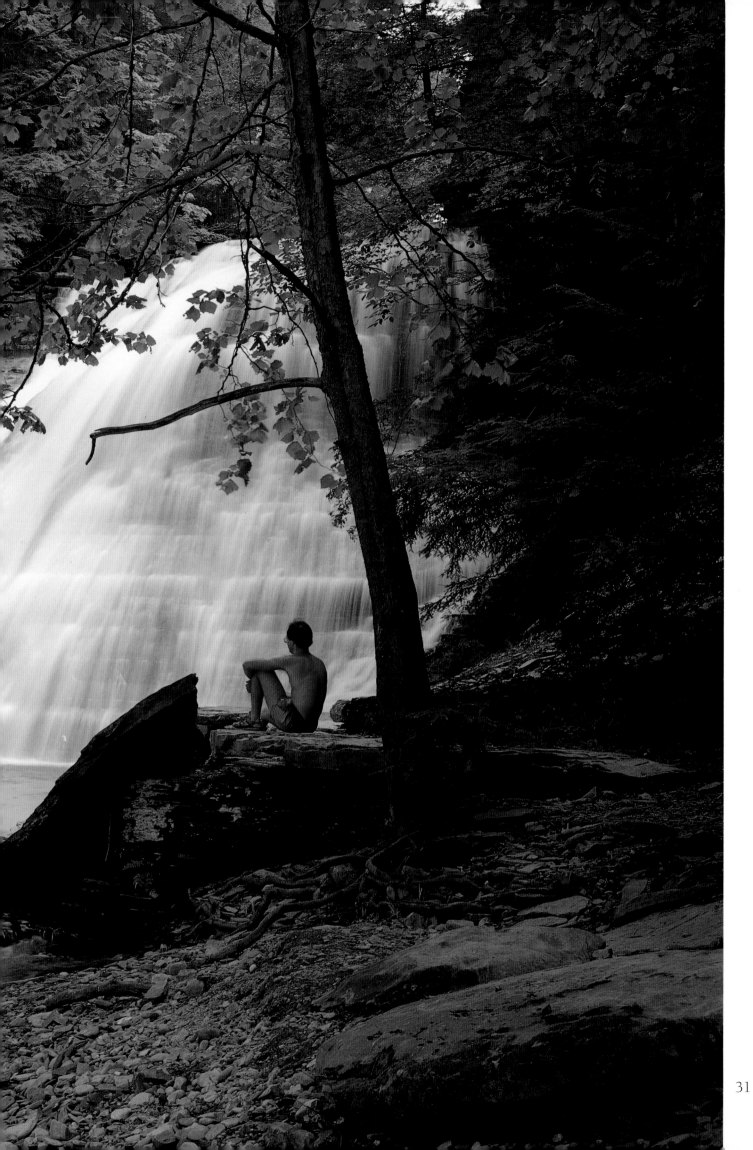

# CASCADILLA GORGE

The name of the Cascadilla Gorge rightfully implies that it's a series of lovely cascades. It spills through a ravine along the southern part of the Cornell campus. What the name doesn't suggest is that it is one of the most studied gorges in the Finger Lakes. Cornell University was home to the locally famous geologist O.D. von Engeln whose book *The Finger Lakes, Their Origin and Nature*,  thoroughly explains the geological development of the area.

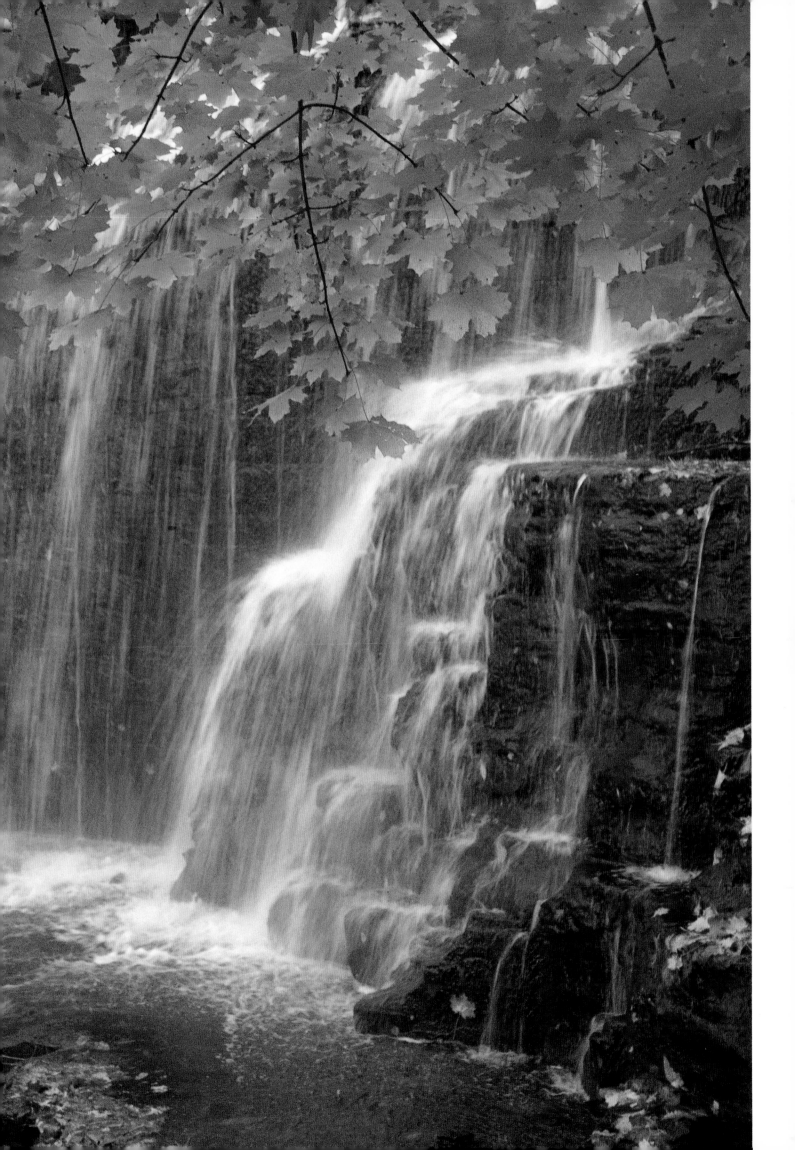

# REYNOLDS GULLY

The two falls shown here are in Reynolds Gully along the southeast end of Hemlock Lake. Reynolds Gully is the biggest of four gorges within a mile's distance that flow into Hemlock Lake, the source of drinking water for the city of Rochester.

In summer, the gentle, cascading waters refresh a hot hiker (me). But in spring the waters are not gentle. Fed by melting snow, they rage through the gullies, pushing boulders along the slippery bottom, uprooting trees and

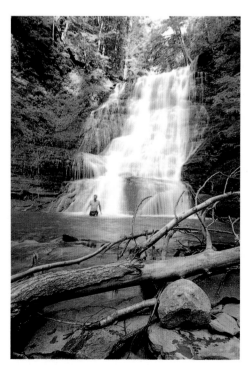

sweeping them through the gorge until they jam with others in a tight tangle at a turn. In spring, water spills from the cliffs in hundreds of rivulets and a few temporary full-size streams, all of them carrying rock away, particle by particle and sometimes in whole landslides.

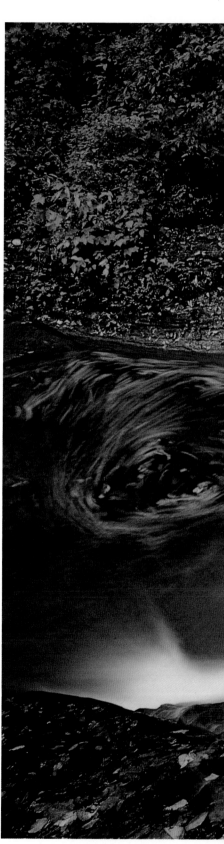

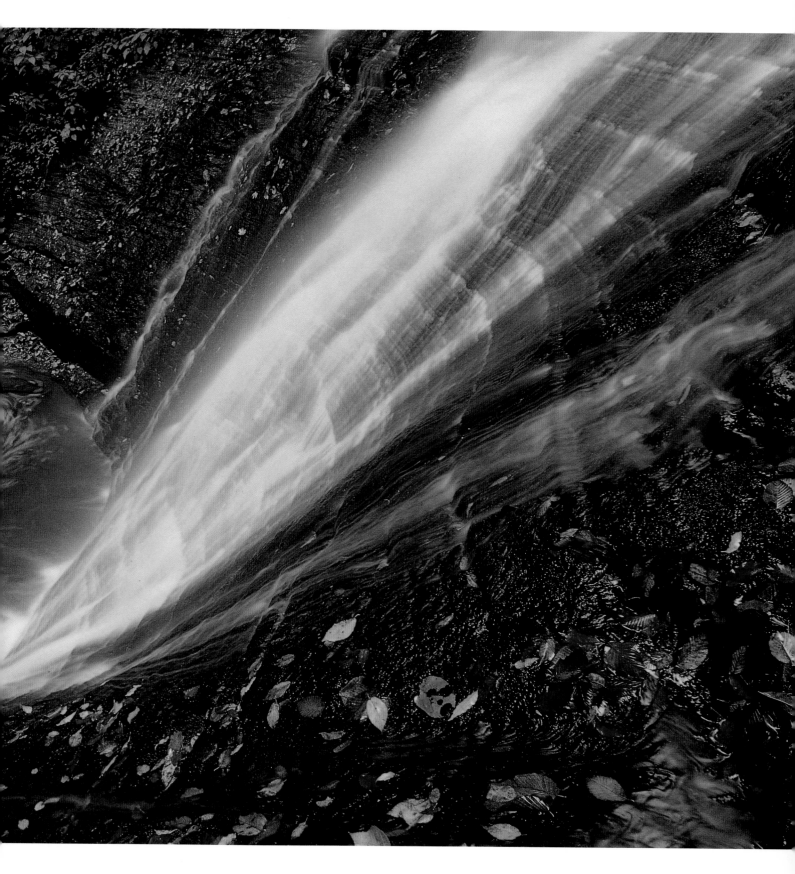

# ITHACA FALLS

Fall Creek is one of two streams, both resplendent with waterfalls, which run through the Cornell University campus and attract much attention. Ithaca Falls, just west of the campus, is the biggest. On warm days and evenings it draws gatherings of students, both in the stream and along the banks. Rings of ashes on the shore-line indicate that the lure of waterfalls does not end with daylight.

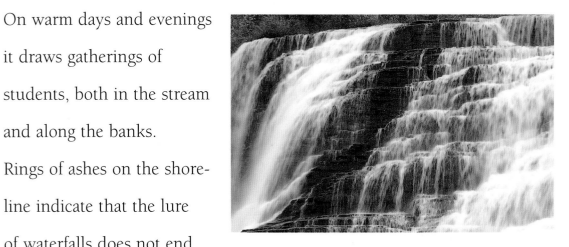

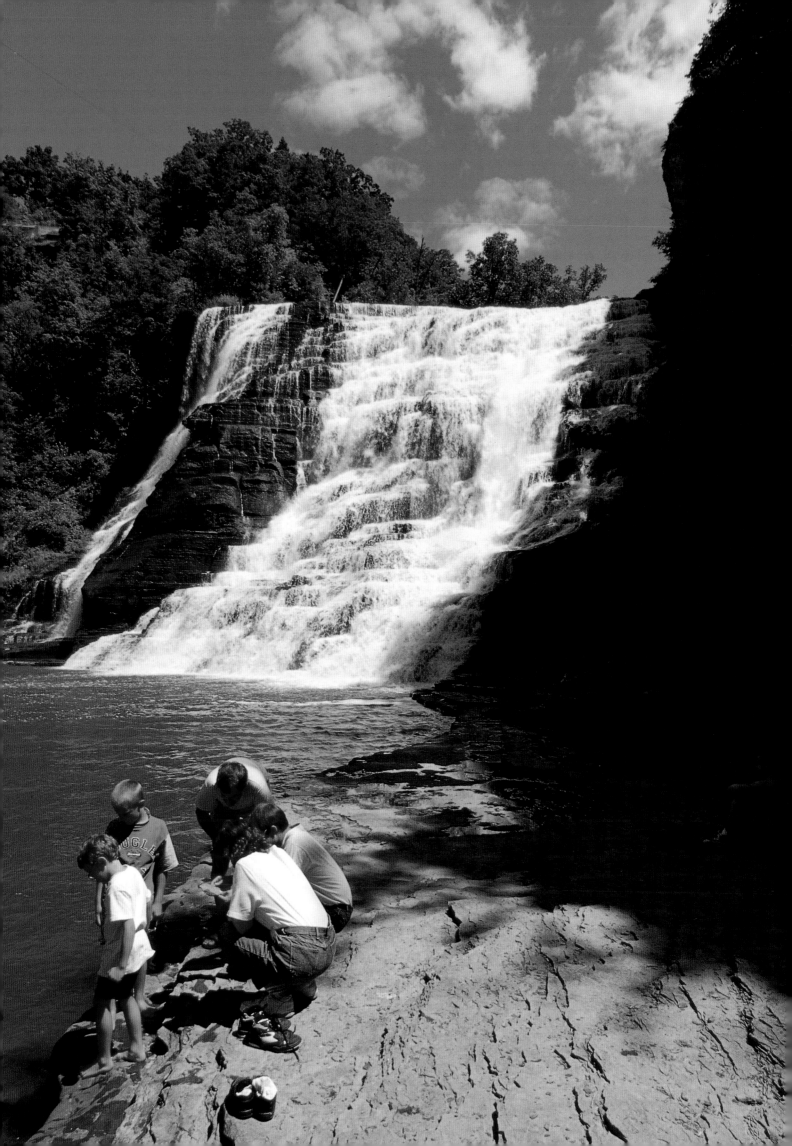

# SALMON CREEK FALLS

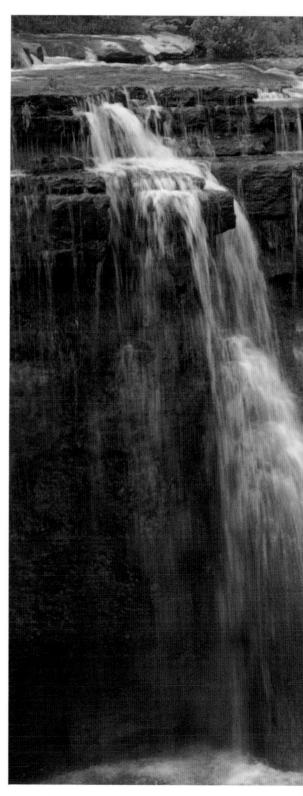

At the rear of a park in the tiny hamlet of Ludlowville is Salmon Creek Falls. If hot weather leaves the stream flowing at even moderate levels, it offers what may be the best waterfall-sitting in the area. And you haven't lived until you've sat in a waterfall. Salmon Creek gives you several choices: float in the deep plunge pool while free-falling water jackhammers onto your head and shoulders; lean against the center outcrop of rock where the cascading waters caress you; or sit atop the large limestone boulder in midstream and luxuriate in the cooling mist that blows over you. Or just stand up on the rim and watch others enjoy themselves.

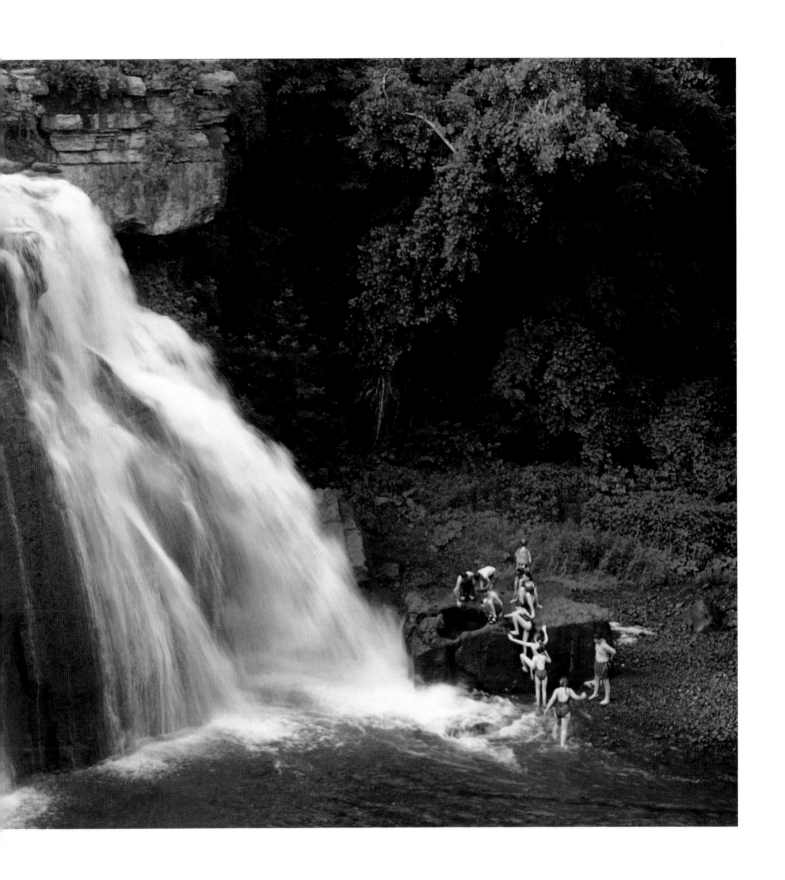

# SALMON CREEK FALLS

Daylilies a short way downstream from the base of Salmon Creek Falls in the hamlet of Ludlowville provide an unusual foreground. A month earlier, the plants were flowerless. Their sword-shaped leaves were covered with rain on a dreary day.

Change on land occurs at varying rates, usually somewhat slower than the growth of flowers which may be several feet in a month. Over a year, continents may move a few inches, mountains may rise or fall by a few millimeters; waterfalls erode backwards a few inches to a few feet per year. Glaciers in a growth cycle seem like speed demons, moving up to a half mile a year and melting back almost that much when they are in retreat. But whether the movement is forwards or backwards, up or down, and whatever the rate, if it is sustainable, time is on the side of land and can make great things happen.

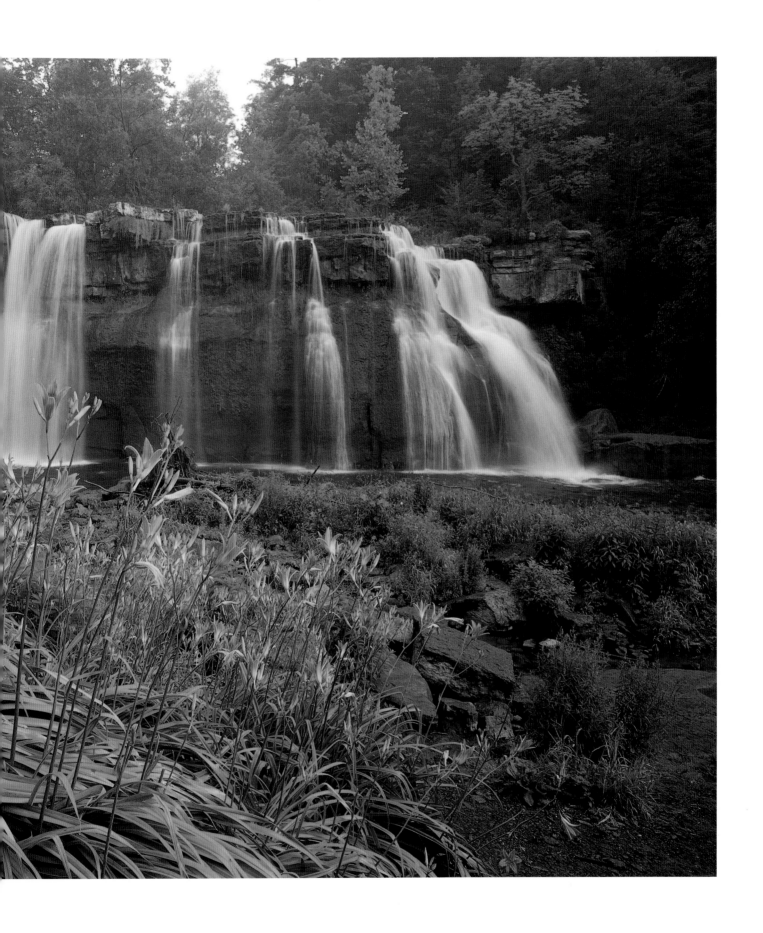

# BUTTERMILK
# FALLS

As twilight descends, visitors to Buttermilk Falls State Park in Ithaca retreat from the swimming pool below the falls to a perch on adjoining walls. The steep hills and abundant streams surrounding Ithaca give it the highest concentration of waterfalls in the Finger Lakes area. Three state parks in the area hold several of these, but many more spill in the numerous surrounding gorges, hidden by the thick canopy of summer leaves.

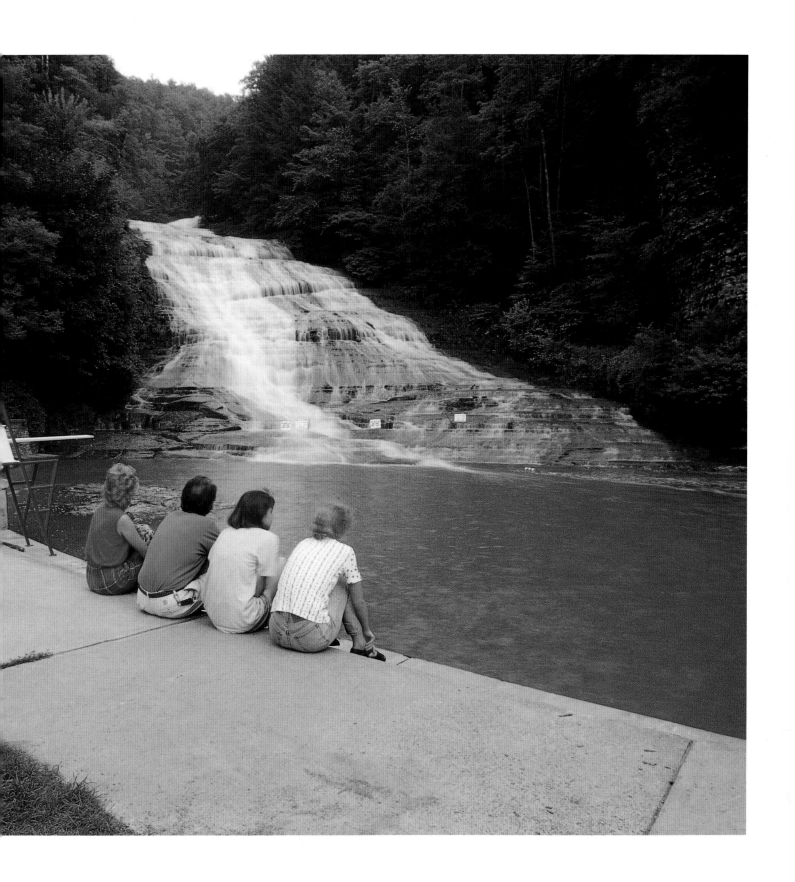

# LOWER FALLS

## ROCHESTER

On its path through the city of Rochester, the Genesee River has three waterfalls of similar size and appearance to the three it flows over in Letchworth State Park. This is the Lower Falls. In a run-down part of the city, it's best known as the annual autumn gathering place for Chinook salmon. As they swim upriver to mate, the fish are blocked by the falls and

accumulate in the hundreds, if not thousands. Swarms of fishermen in yellow and orange rubberized suits line the adjacent banks and surround the falls, jockeying for a good spot to hook a 30-pound prize. The skyscraper in the background is the head-quarters of Kodak.

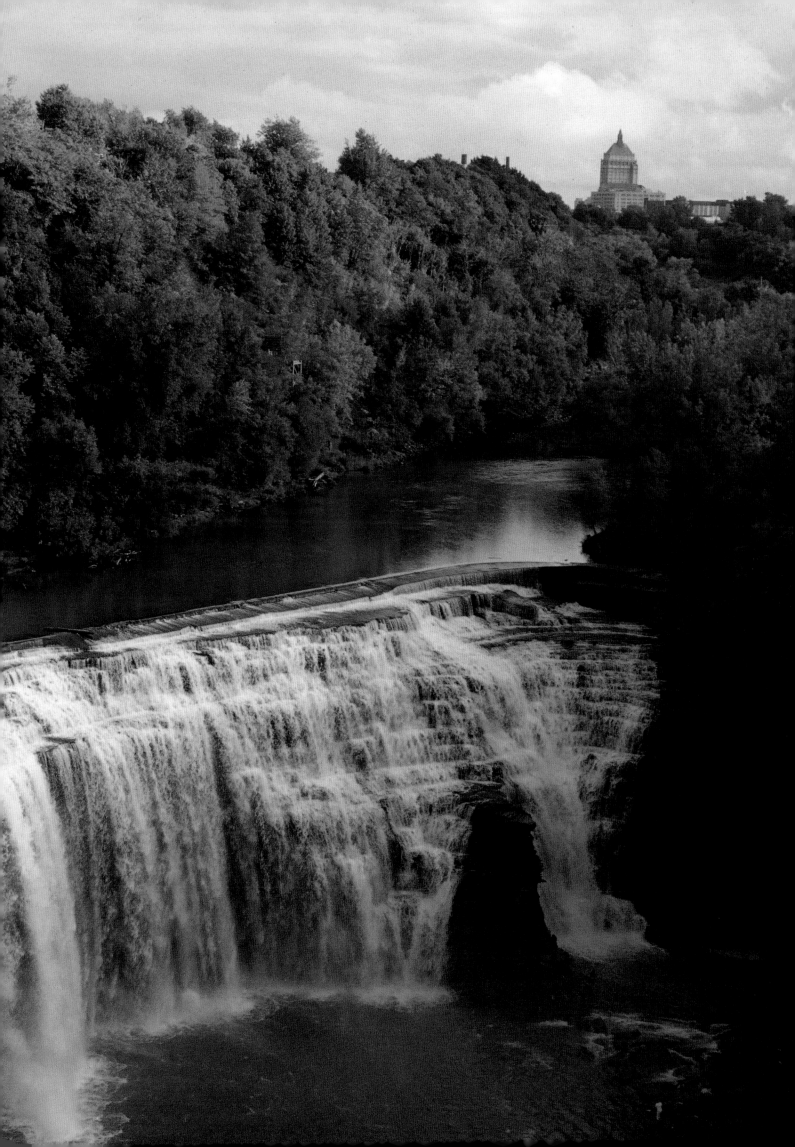

# UPPER FALLS

## ROCHESTER

A decrepit and abandoned
building contrasts starkly with the falls. On
summer evenings, a high-tech, state-of-the-art
laser show flickers across gorge walls hundreds
of millions of years old. The nearby High Falls
Center tells the history of Rochester and the
importance of water power to the city's develop-
ment. Like waterfalls throughout the region, this
one attracted much industry and, at one time,
powered some 21 gristmills giving Rochester
its original nickname—"Flour City." Upon
the demise of the mills, the dowdy "Flour City"
was transformed into the more attractive
"Flower City."

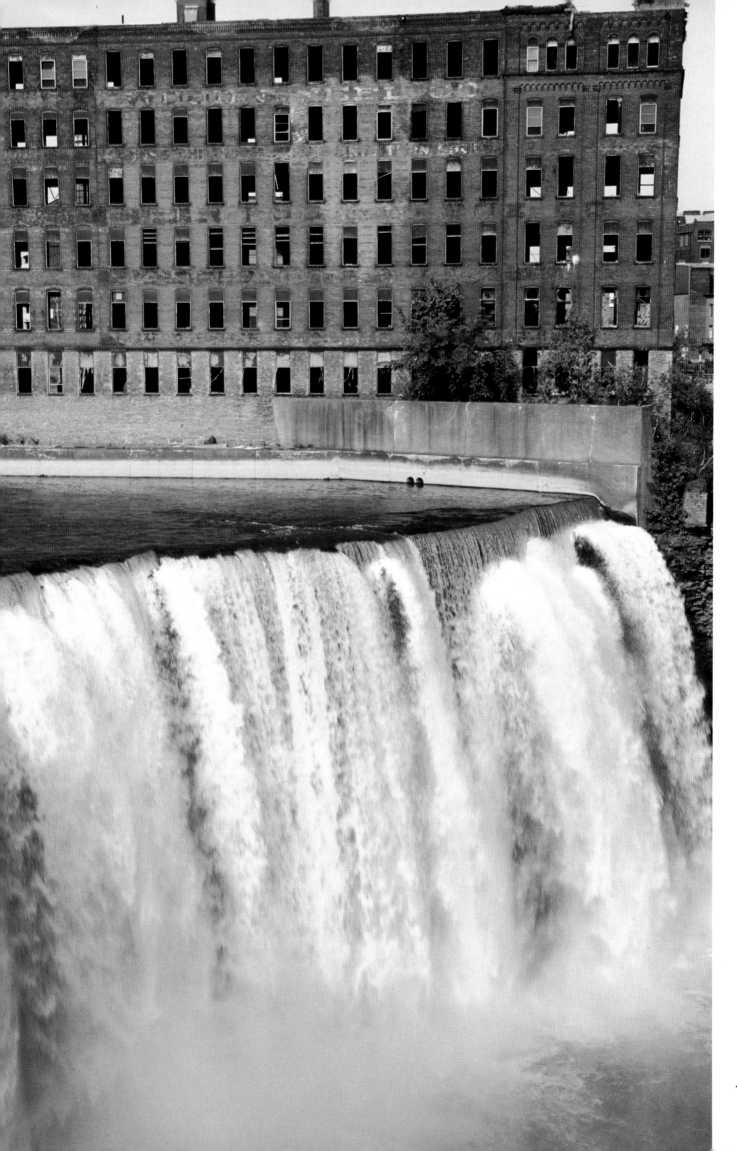

# KEUKA OUTLET

Running from the north end of
Keuka Lake into Seneca Lake near Dresden, the
Keuka Outlet stream is the only natural connection
between any of the Finger Lakes. An excellent
hiking and biking trail runs along the stream and
past the remnants of a railroad, a canal and several
old mill sites. Here, at Keuka Outlet Falls, only
a few walls remain from one of the mills.

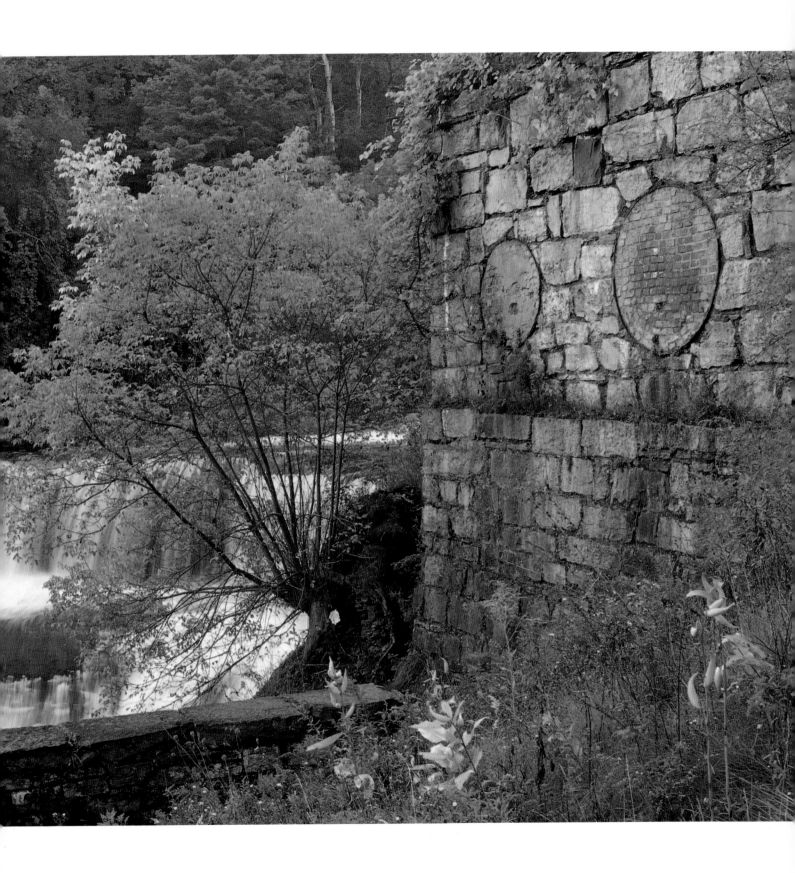

# CARPENTER FALLS

Could a United States president have dallied behind the waters of Carpenter Falls? It seems likely, as Millard Fillmore, our 13th President, was born only a few miles down the road. If so, then it's likely he saw this waterfall in all seasons and maybe, like modern youths, even scratched a few love notes into the rocks behind the falls.

Here, recent rains have replenished the autumn stream and knocked down enough leaves to open a view through the woods. In winter, the falls gradually freezes from both top and bottom until it's frozen solid and looks like an inverted thumb pushing down on a table, while ten- and twenty-foot fangs of ice cling to the adjacent cliffs. 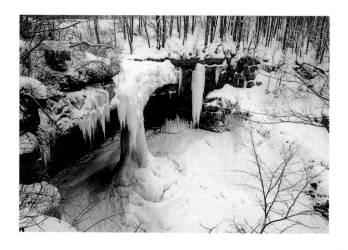 In spring it gushes through the air as if a dam had broken, while by midsummer it's a mere trickle with less volume than a garden hose.

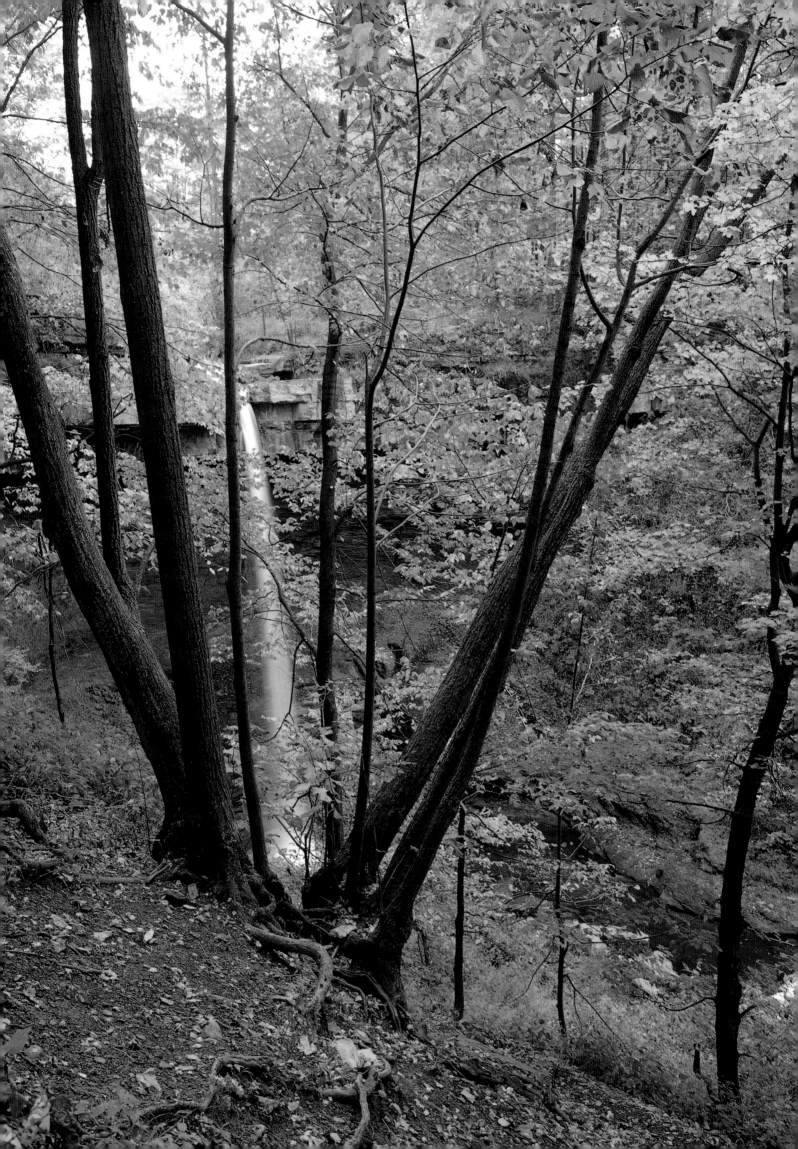

# HAMMONDS-PORT GORGE

What do you see in this picture? Most of us see some small trees clinging to a cliff. Their leaves have turned yellow. Where is this scene? In the here and now, it's in a gorge in Hammondsport. In the there and then, it was in the middle of an ancient tropical seabed. Prehistoric sharks circled overhead, dinosaurs sloshed through the shallows.

When you stand at the bottom of this gorge— or any other—and look up, you see hundreds of millions of years of earth's history. You see rock particles from ancient mountain ranges. You are in the classroom of nature looking at a cross section cut into a seabed.

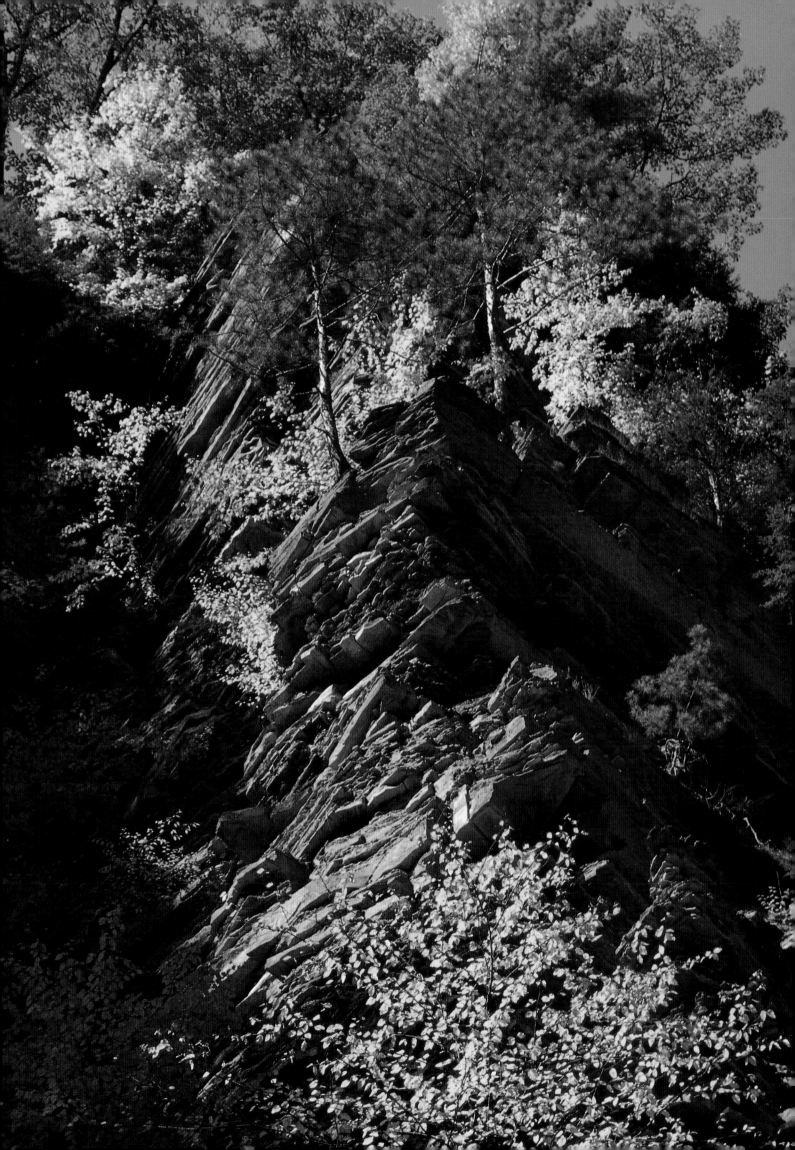

# CONKLIN GULLY

Textures of rock and water are a repeating theme throughout the gorges. The textures of rock are real and palpable; they can bruise and skin fingers and knees. The textures of water are primarily visual. Water textures evoking corduroy, herringbone and satin appear and subside as currents converge, pass over shallow rocky bottoms, enter a deep channel, or stretch thin before the crest of a waterfall. Here, late evening sunlight reflects from a cliff wall onto the water and shore, revealing similarities in texture.

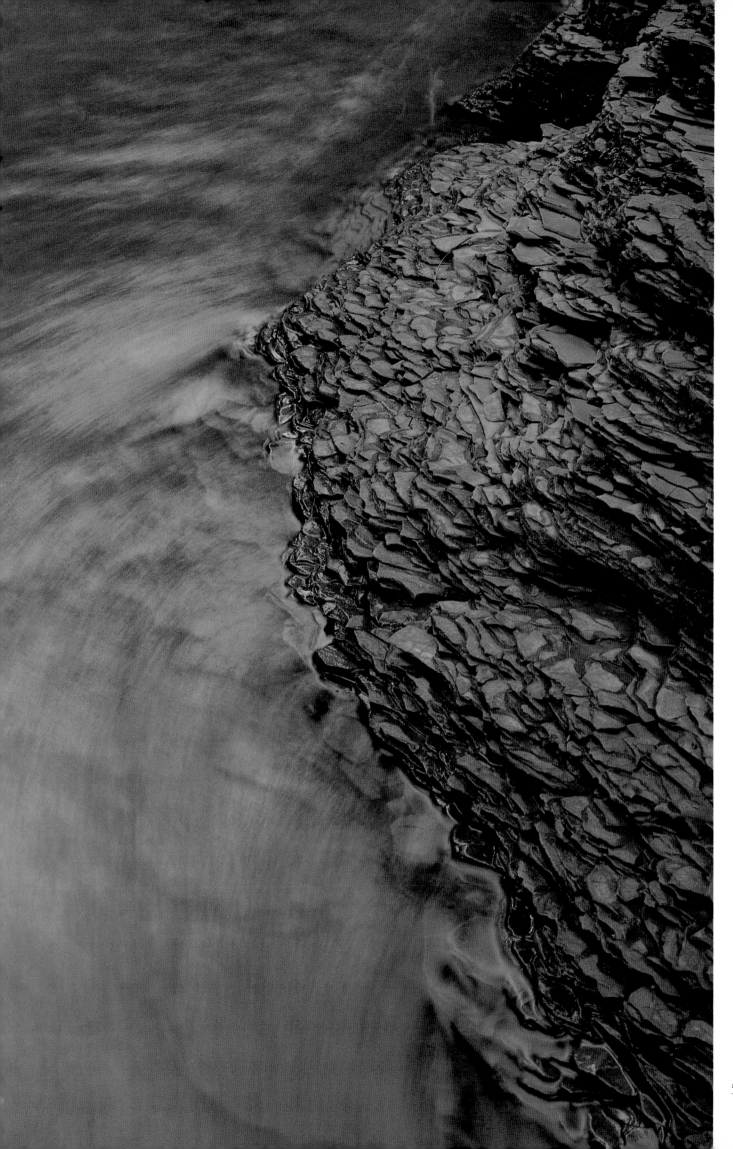

# CONKLIN GULLY

Death walks the gorges frequently, in many forms. The occasional carcass of a raccoon or deer indicates that even sure-footed animals succumb to the treacherous cliffs. But no life seems more at risk than trees.

The remains of a fallen forest-dweller the size of a telephone pole attest to the  short life span for a tree growing along a gorge bank. This lone trunk, stripped of bark and limbs by years of decay, leans like a skeleton against the gorge wall. Pushed by swollen spring waters until they jam into a bend in the gorge, fallen trees often create a formidable barrier through which hikers must twist and turn to make their way.

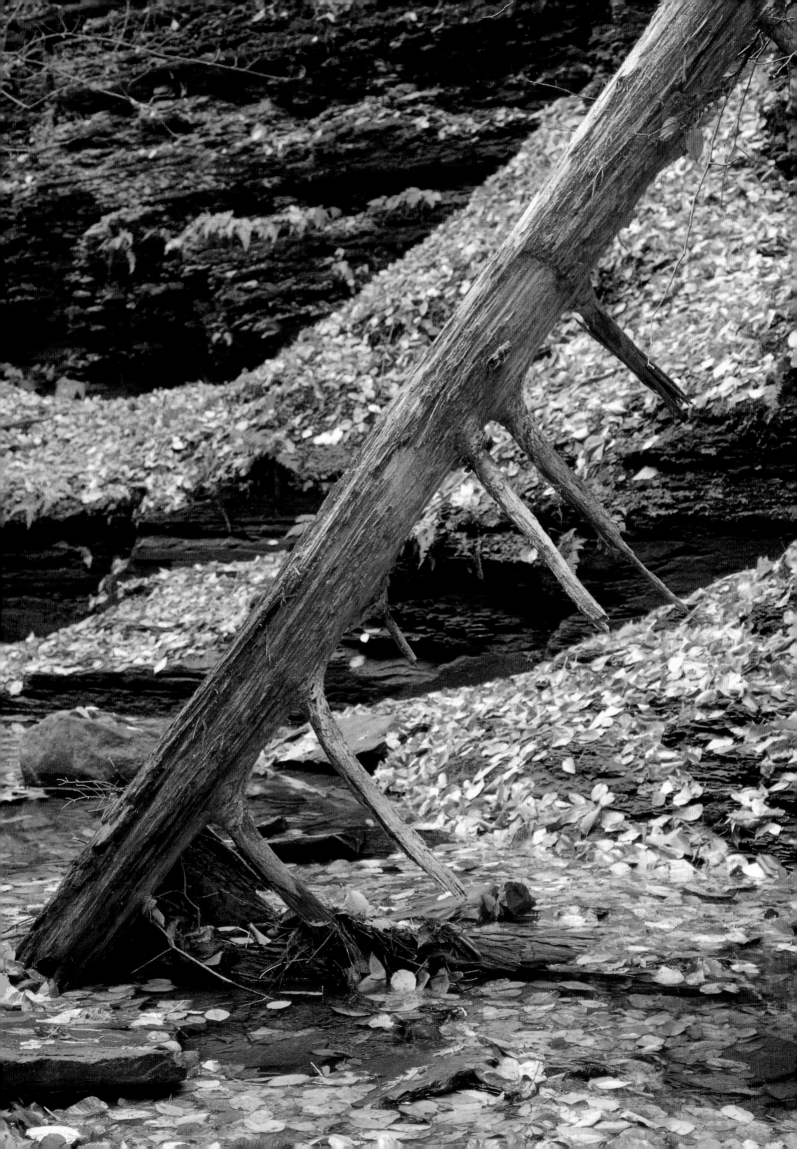

# FRONTENAC GORGE

While the gorge behind the falls is narrow and dark, at the brink of the precipice it opens like a doorway to reveal a sliver of Cayuga Lake in the distance. Most gorges are like that. Walking down a stream to its major waterfall is like walking through a hallway to an auditorium. The gorge in front of a falls is always larger than the gorge behind it. That's because waterfalls walk backwards. The retreating movement carves out the largest part of a gorge, like a person flailing his arms while walking backward through a wheat field.

That a waterfall walks backwards is observable. It's readily apparent where it is eroding the land— beneath it and in front of it. In the winter, spray from the falls clings to cliffs downstream and pries rocks loose to enlarge the gorge. In spring and summer, the stream's flow pushes out rocks in its path, moving the waterfall backwards.

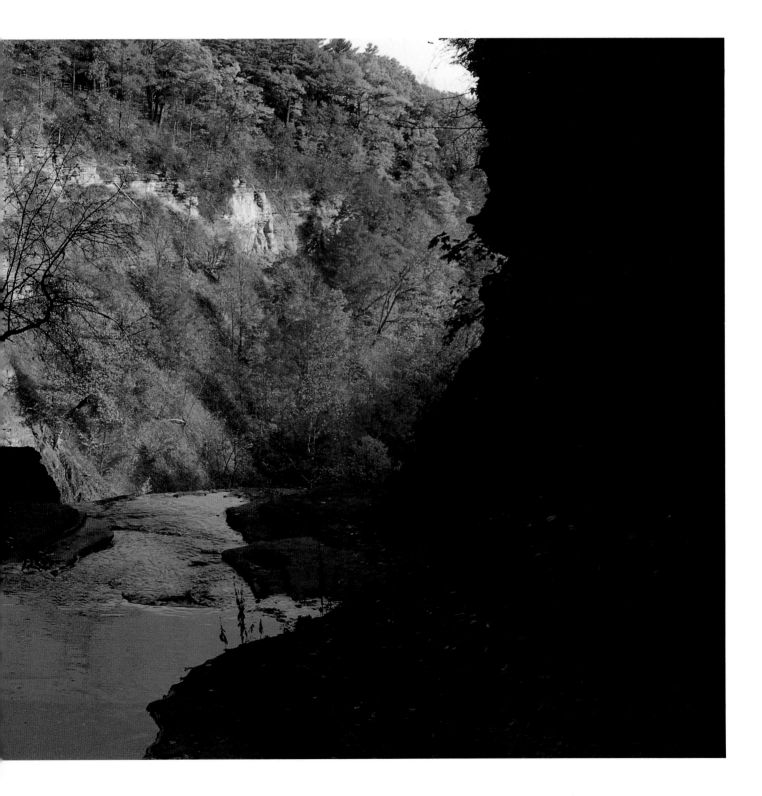

# LUCIFER FALLS

## TREMAN STATE PARK

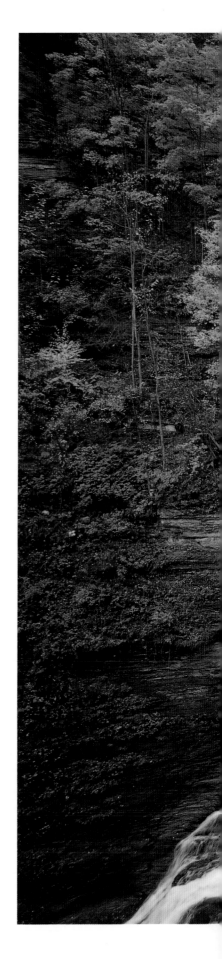

At the upper end of Enfield Glen, a short hike from the parking lot and accessible by well-maintained trails on either side of the gorge, stands Lucifer Falls, 112 feet high. Like all the other waterfalls, it works its way back upstream over the decades. The speed at which they move varies. The mighty Niagara Falls has moved backwards seven miles, or as much as three or four feet a year, over 12,000 years. Taughannock Falls has moved upstream nearly one and a half miles, or less than a foot per year in about the same span of time. Other falls walk backwards only a few inches a year. But back they all go, and thousands of years from now, as they reach ever higher and gentler slopes, they'll dwindle in size until they are no more.

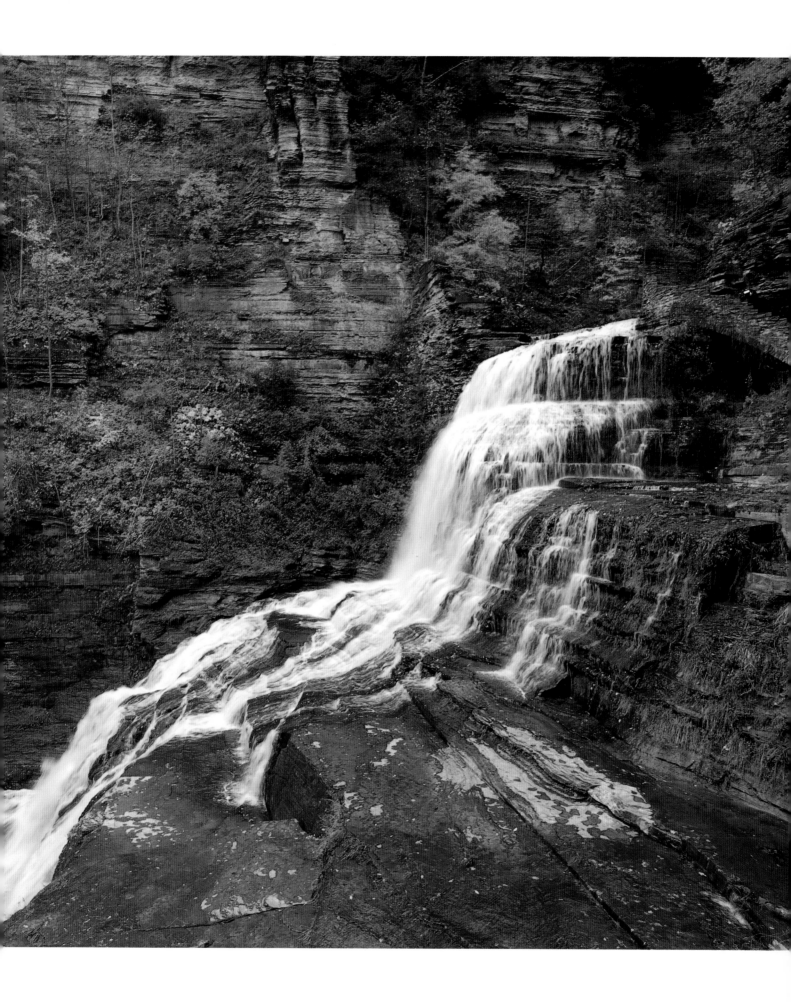

# TAUGHANNOCK FALLS

Taughannock is the tallest waterfall (214 feet) in the Finger Lakes. With the exception of the Letchworth chasm along the Genesee River, it also boasts the largest gorge. You can walk to its base via a

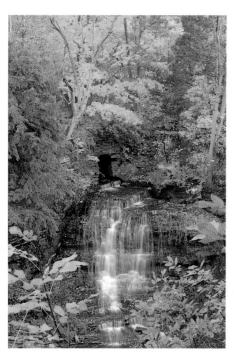 wide and level footpath or gain a grand view from a spectacular roadside overlook. With the gorge over a mile long, and a couple of hundred feet wide and deep, you might wonder where all that rock went. The stream simply carried it into Cayuga Lake, where it accumulated as a large delta that's now a state park. The Finger Lakes are dotted with deltas of varying sizes, each built of rock deposited by streams.

*Overleaf*: Taughannock overlook

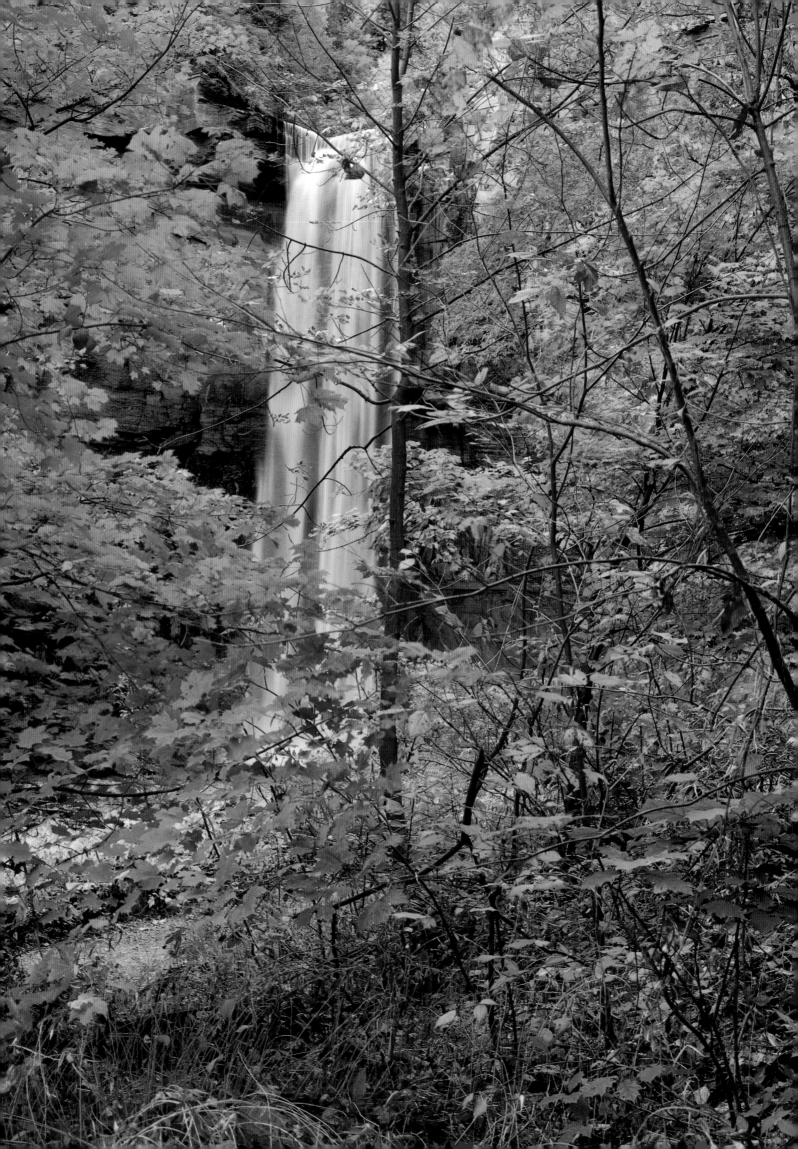

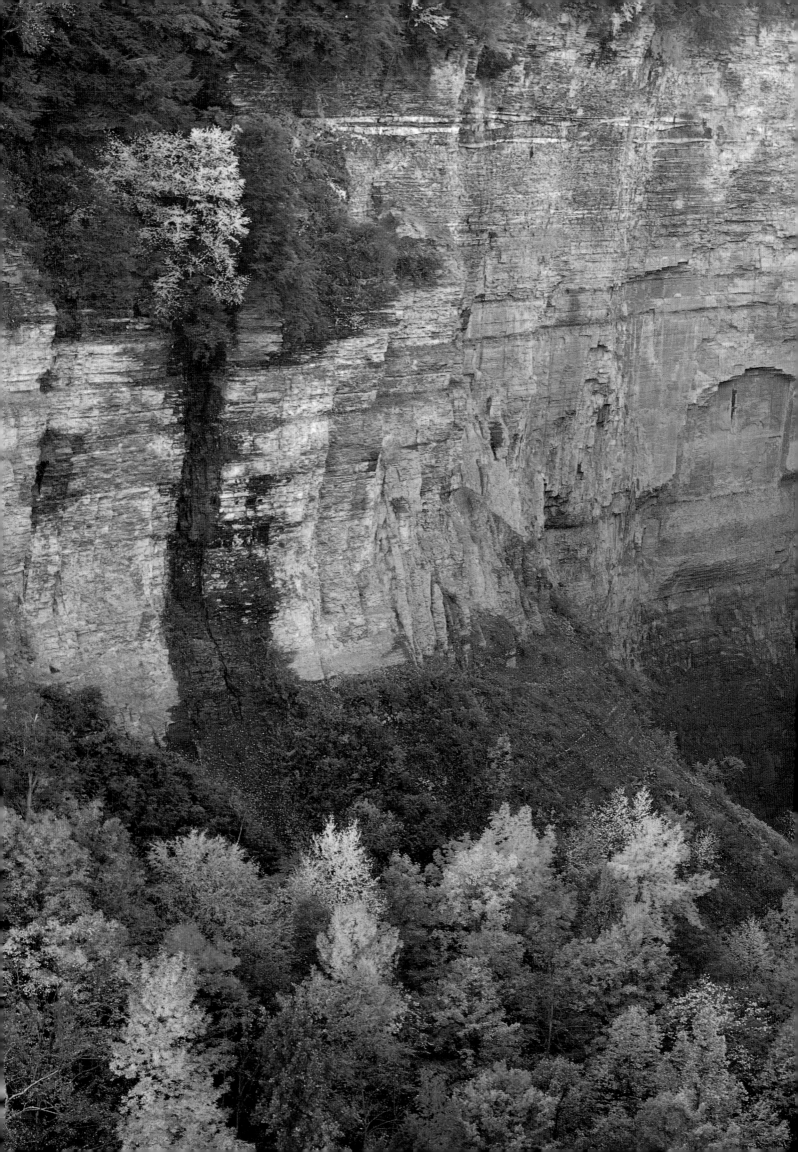

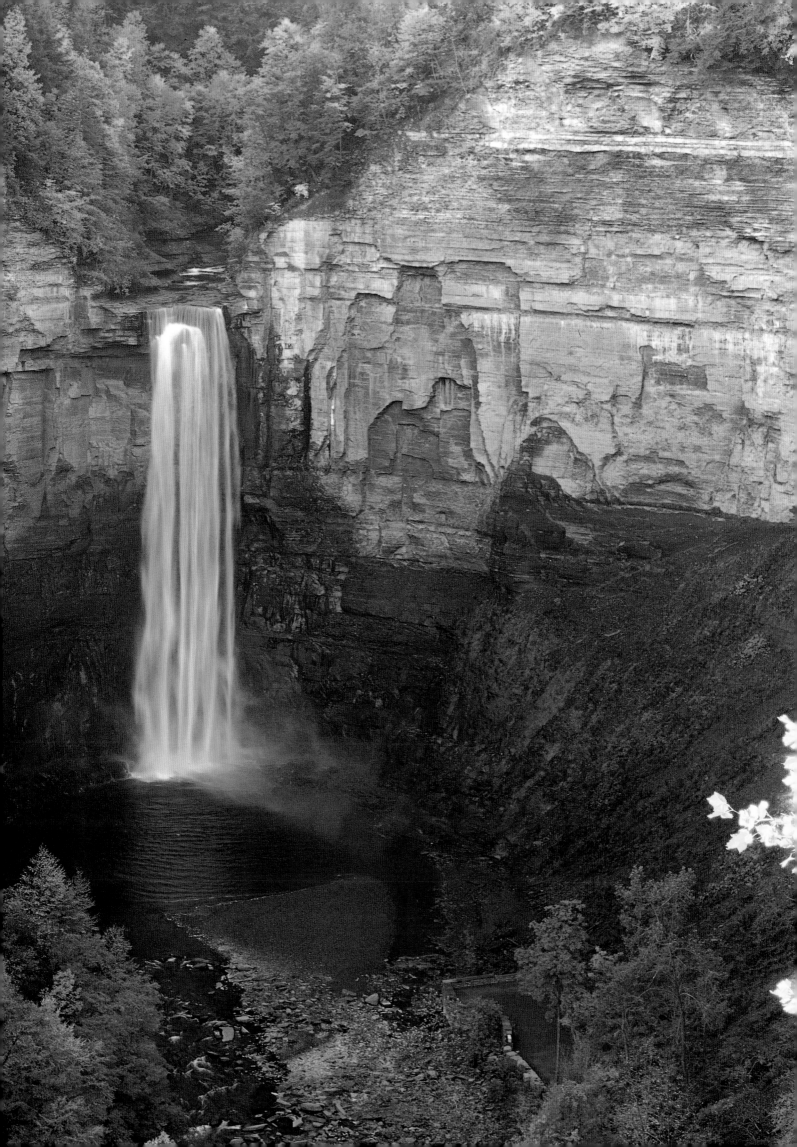

# HAVANA GLEN

My ideal gorge is Havana Glen. It's easy to reach—just a few steps along a well-maintained (but very short) trail starting at the back of a parking lot. It's primitive and rugged-looking. Steep shale cliffs leading to the waterfall climb skyward and shape your path. The stream twists and turns through a narrow rock channel surrounded by ferns and cedars. It's uncrowded. Nearby Watkins Glen draws the big crowds. And in summer,  you can stand in its waterfall, which here looks like a mere water faucet. In the rainy season a curtain of water twenty feet wide slides over the rock.

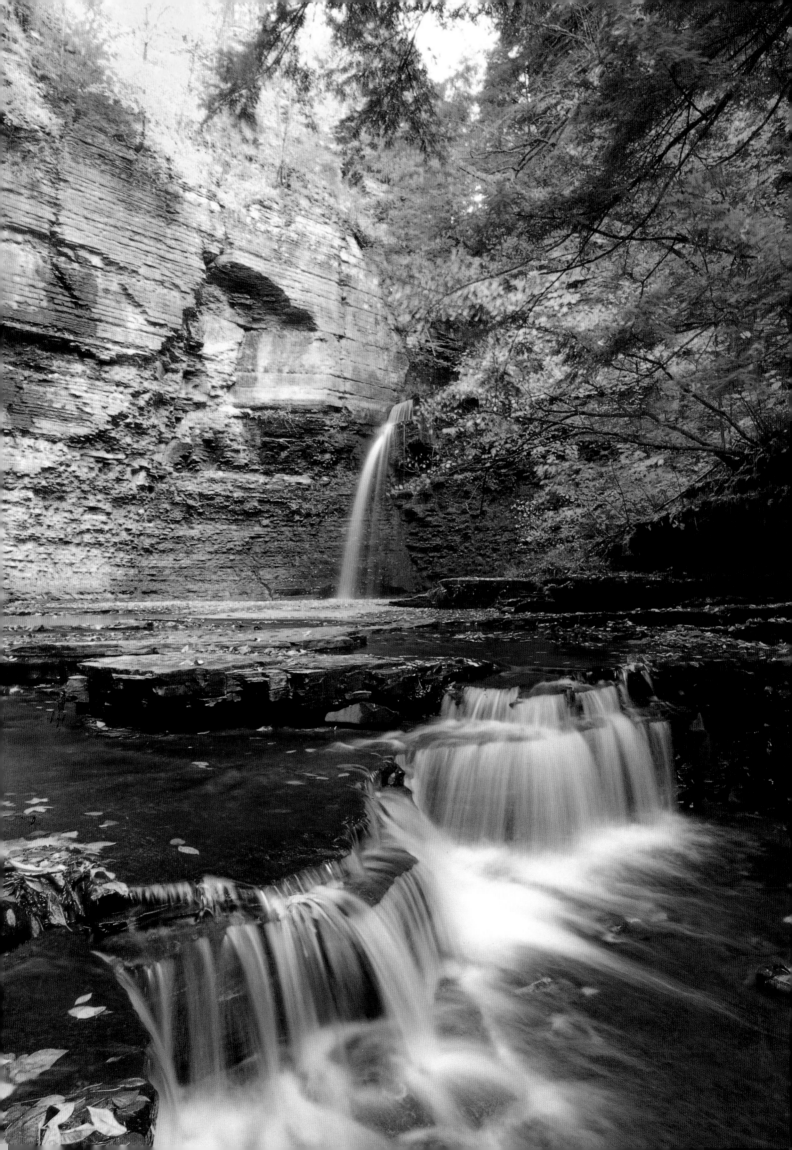

# HAVANA
# GLEN

Pay your dollar to the old gentleman in the booth at the Havana Glen parking lot and Eagle Cliff Falls will be yours to view after a five-minute walk. As in most of the developed gorges, here a trail leads you to the falls. In photographing, the challenge sometimes is to get an angle different from the one afforded by the trail. Inevitably, the trail shows you a waterfall head-on. Fine for viewing, but not always so good for photographs.

Confined to a flat piece of paper, a two-dimensional image often benefits from a side view, where you can easily add foreground and even background. A side view also reveals the falls reaching out across the picture, instead of simply dropping straight down. All these techniques seem to give more depth to a photograph, and make it seem more real.

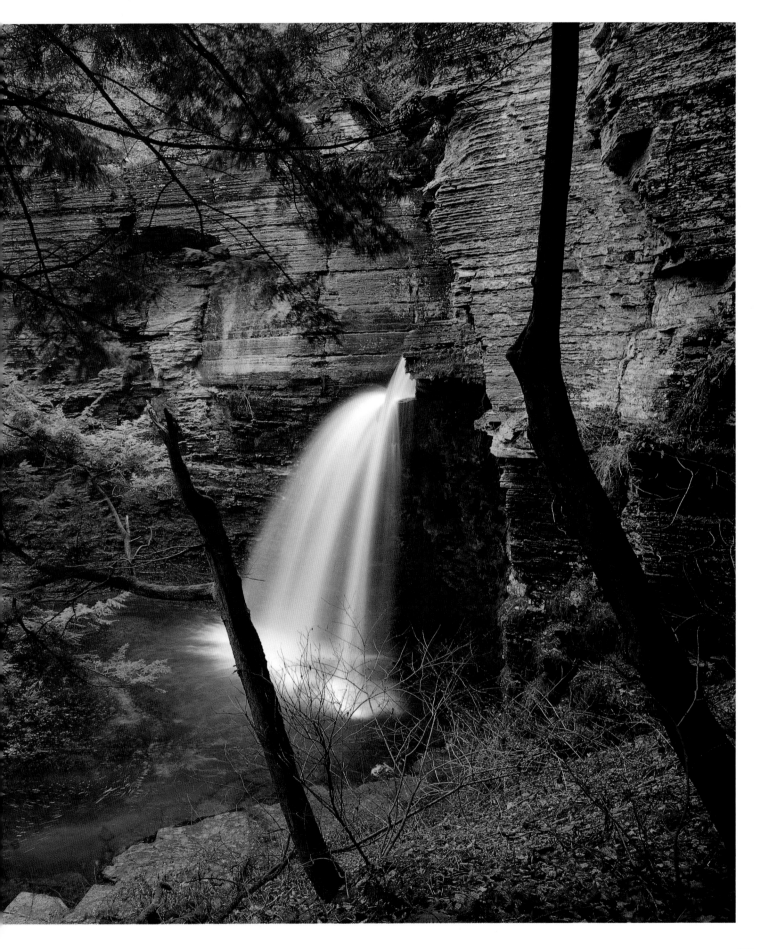

# CLARK'S GULLY

## HIGH TOR

The opening carved into the
cliffs by this eight-foot waterfall is the gate-
way into a rugged, treacherous, undeveloped
gorge. Clamber up this falls and you will
come upon another eight-footer. Should you
manage to cling to the cliff and make your
way past it, an eighty-foot cascade awaits
you at the upper end of the gorge, but
only after a strenuous and risky climb.
Only the agile and fit should explore this
gorge, which has no trails.

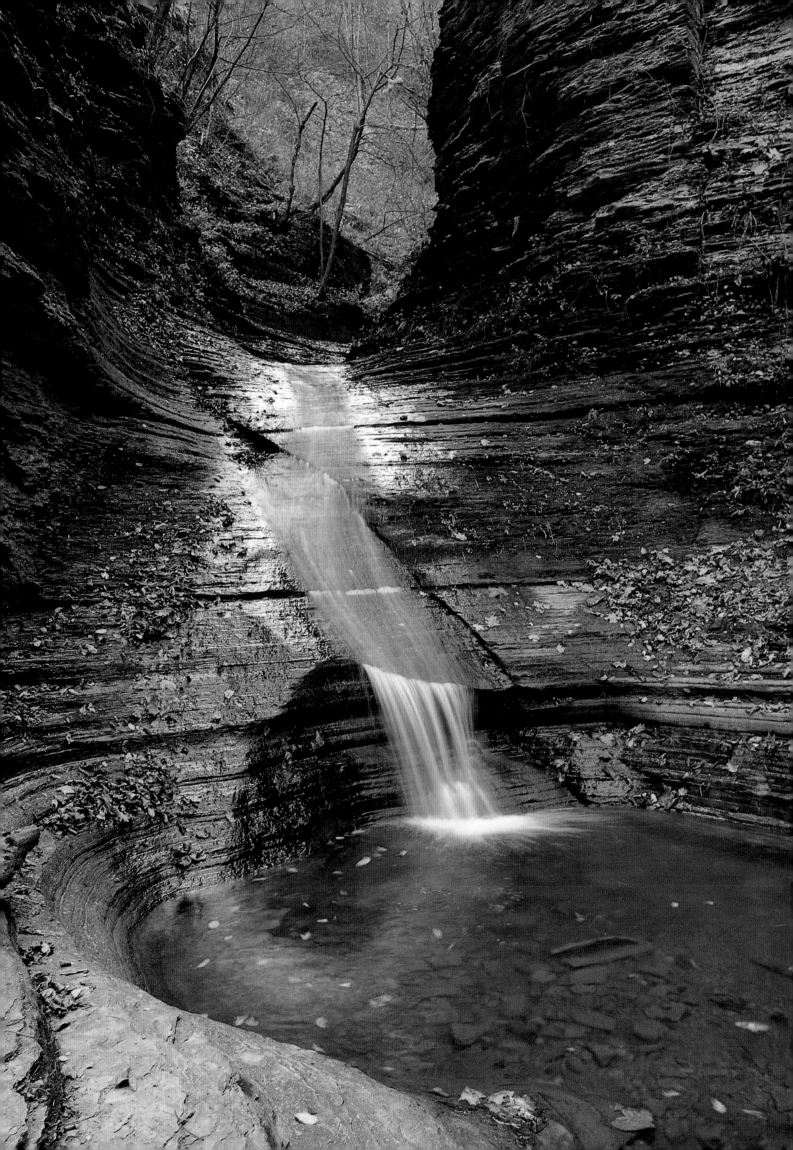

# MIDDLE FALLS

## LETCHWORTH STATE PARK

One of three falls along the
Genesee River in Letchworth Park, Middle Falls
is the biggest, prettiest and most accessible—
adjacent to a parking lot and visible from several
overlooks, including Inspiration Point, where this
photo was taken. An uncommon north-flowing
river, the Genesee was dramatically affected by
the last ice age. Geologists believe that each of

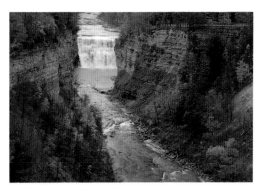

the three waterfalls devel-
oped separately during the
retreat of the last glacier.
With the glacier functioning
as a dam, meltwater from
the glacier formed a lake south of the ice.
When the glacial dam broke, a river roared
out and carved the waterfall. Three times the
dam broke and reformed at a lower level—
thus, the three waterfalls.

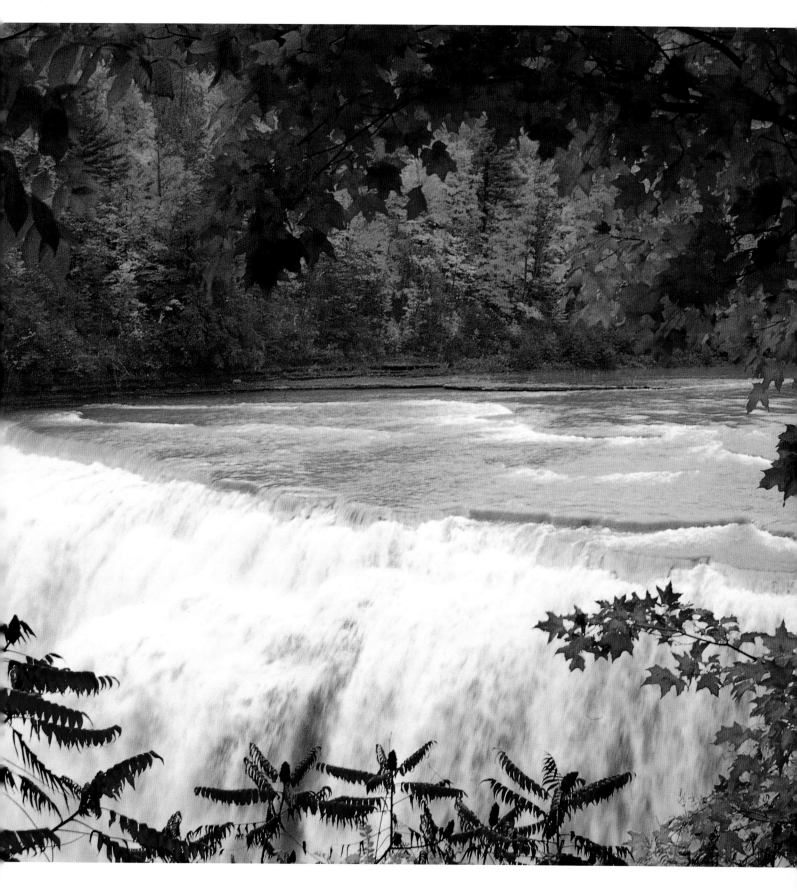

# ENFIELD GLEN

## TREMAN STATE PARK

Long channels running
straight and true seem unnatural. And
sometimes they are, having been cut to
direct water to a sawmill or gristmill.
But usually, like this one, they are wholly
natural, resulting from the type of rock
which, instead of crumbling, cleaves

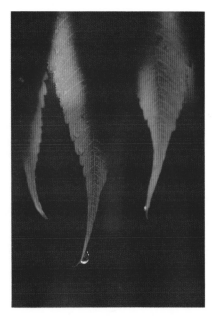 in a straight line

along structural

joints in the stone.

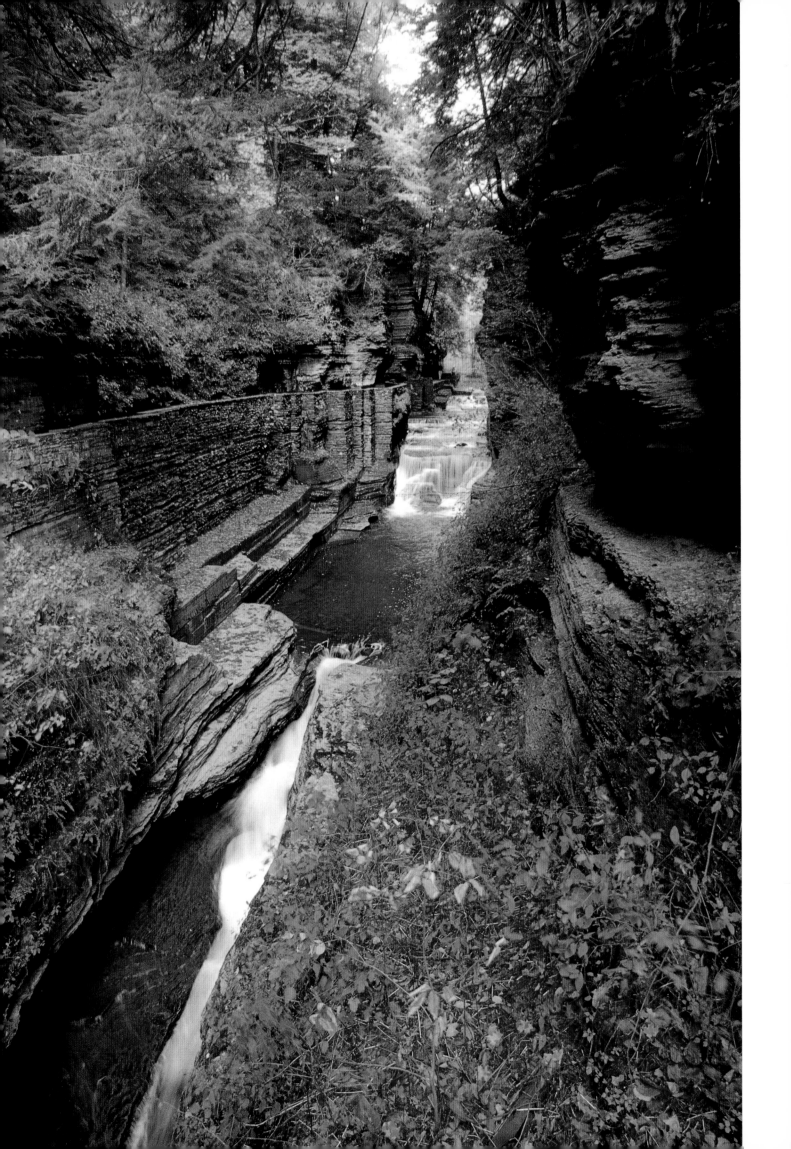

# LOWER FALLS

## TREMAN STATE PARK

Looking like finely combed hair, this falls cascades into a swimming pool at Robert H. Treman State Park.

Waterfalls come in two common forms: free-falling and cascading. But, within that, they often take on the appearance of a variety of common hairstyles. The nature of falling water seems to assume the form of strands. Like hair, these can be gathered, separated, layered, tangled, and even shaven bald. As you look at these pictures, you can see ponytails, pigtails, rat tails, braids, bangs, layered cuts, bowl cuts, even receding hairlines.

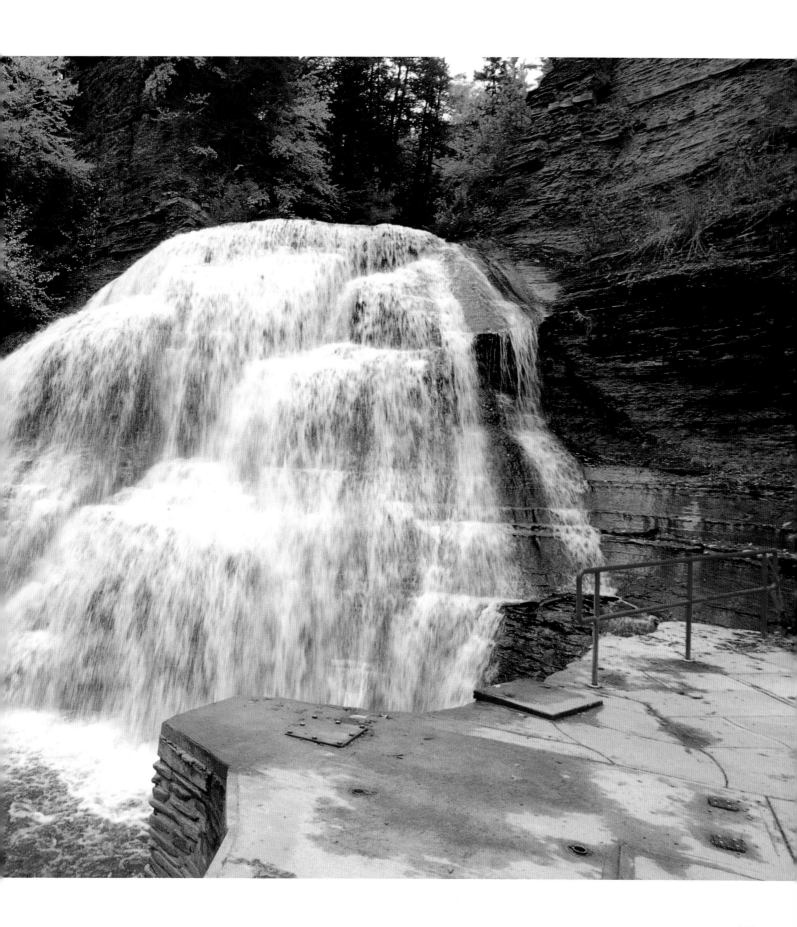

# WATKINS GLEN

With several hundred thousand
visitors every year, Watkins Glen State Park is the
best known of the Finger Lakes gorges. Its steep
mile-and-a-half-long, stone-paved trail leads through
a narrow, twisting ravine and under a few waterfalls.
In the stream are many potholes, which look like
sunken hot tubs. Originally, these were little more

than small depressions
in soft rock. Carrying
pebbles and sand, the
stream swirls around the
holes gouging them ever
wider and deeper until
several connect. In this
manner, much of the
middle and upper gorge
has been carved.

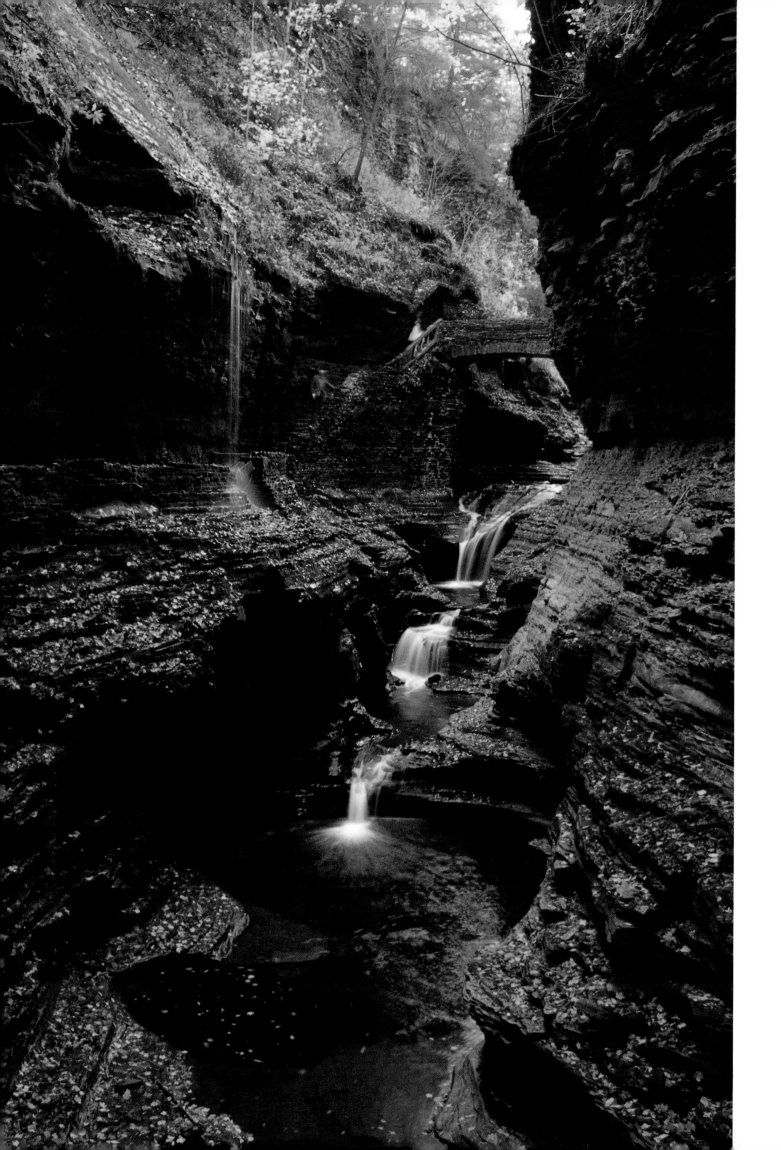

# FILLMORE
# GLEN

The two main falls of
Fillmore Glen are at opposite ends of
its state park. Just a short hike from
the lower parking lot, this falls, at the
mouth of the gorge and the bottom
of a steep hill, evokes a sense
of wilderness.

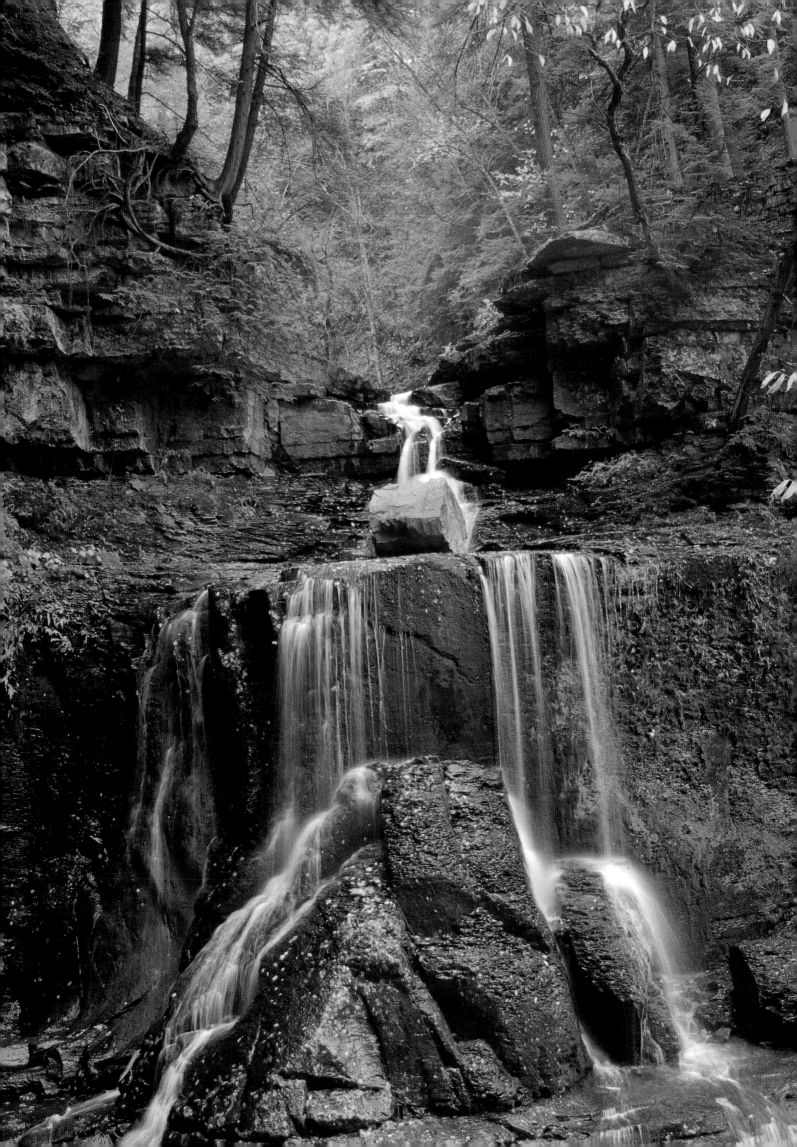

# FILLMORE GLEN

Relatively rare, a whirlpool of leaves depends on just the right stream conditions.

Too much water carries the leaves away. Too little leaves them stranded. Because of the harsh conditions in a gorge, leaves there change color and fall sooner, a week to ten days before those outside. From October 7 to October 17 is a good time to hike a gorge to see leaves swirling down the stream. You can blur their motion in a photograph by using a tripod and a slow shutter speed (1/8 to 1/2 second).

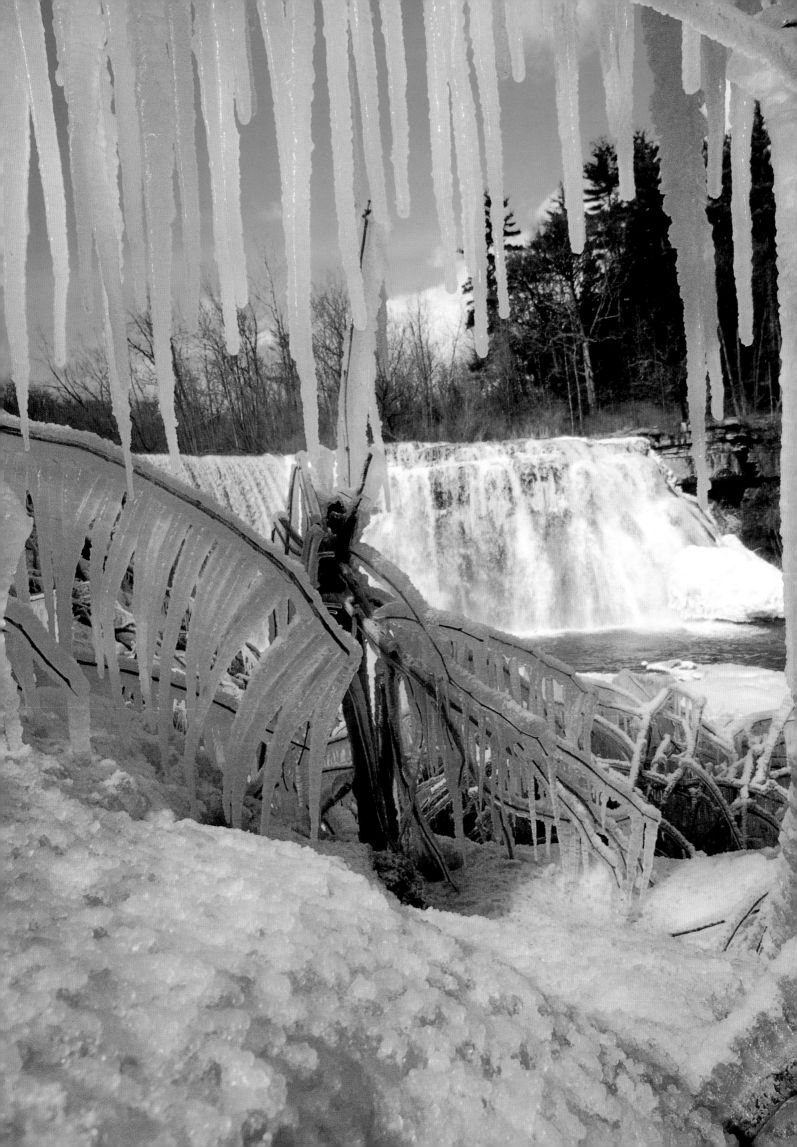

# TINKER FALLS

A frozen waterfall poses many possibilities. For a middle-aged photographer, it poses a risk of collapse. On private property, it poses a liability for the landowner. On the public lands of Labrador Recreation Area, the frozen Tinker Falls, with its gentle starting slope, poses the perfect challenge for beginning ice climbers to strap on their crampons and practice. With helmet and safety rope, this climber was taking his first step up the vertical portion of the ice fall, while several companions watched.

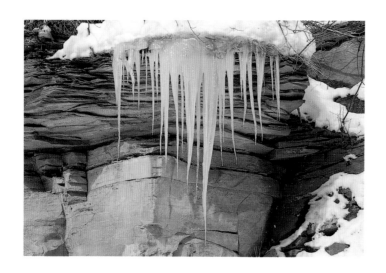

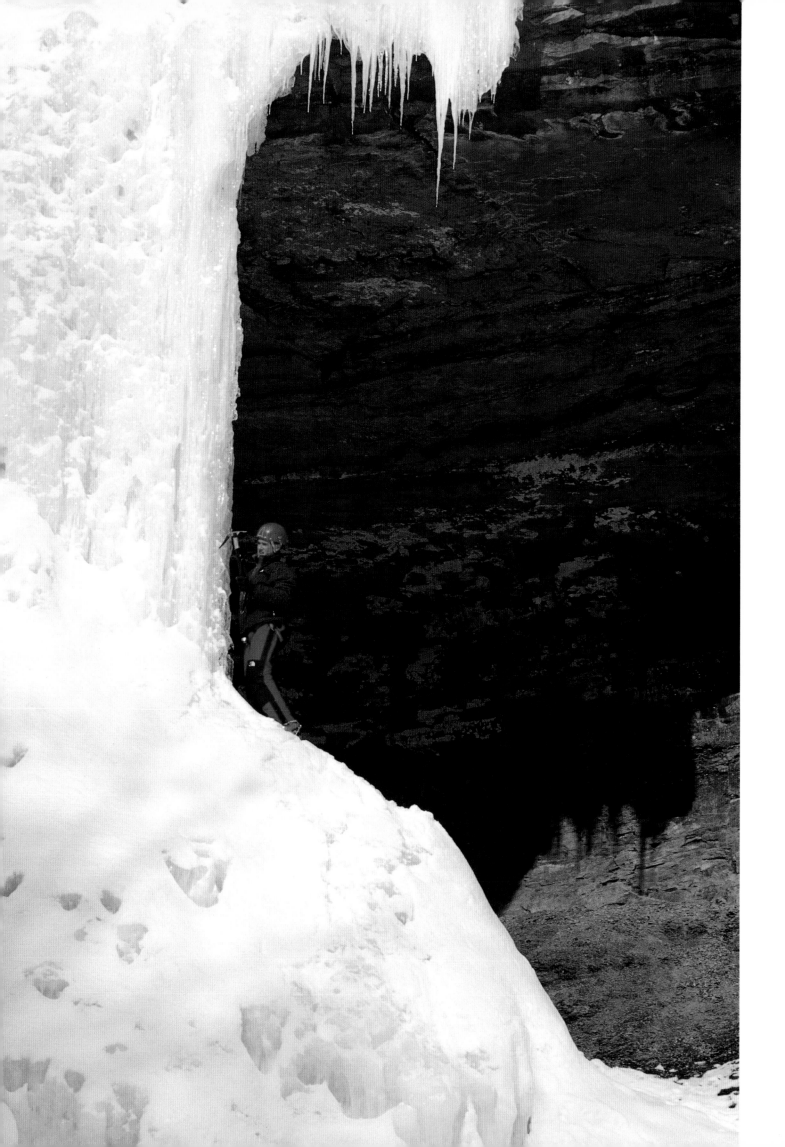

# GRIMES
# GLEN

Icicles upon icicles.
Everywhere, icicles. Tiers and terraces of
icicles climbing upward, shimmering and
glimmering, sparkling, spangled, every one
a tangible expression of the word "dazzle."

Dangling from every surface available on
this hundred-foot cliff, they seem innocent
in their wonderland display. They aren't. In
a gorge, icicles are a major force of change.
When water seeps behind rocks and freezes,
it expands. What happens when water
freezes in a pipe or a bottle? The same here.
But instead of bursting, rocks are pushed
out of the cliff, ever widening the gorge.

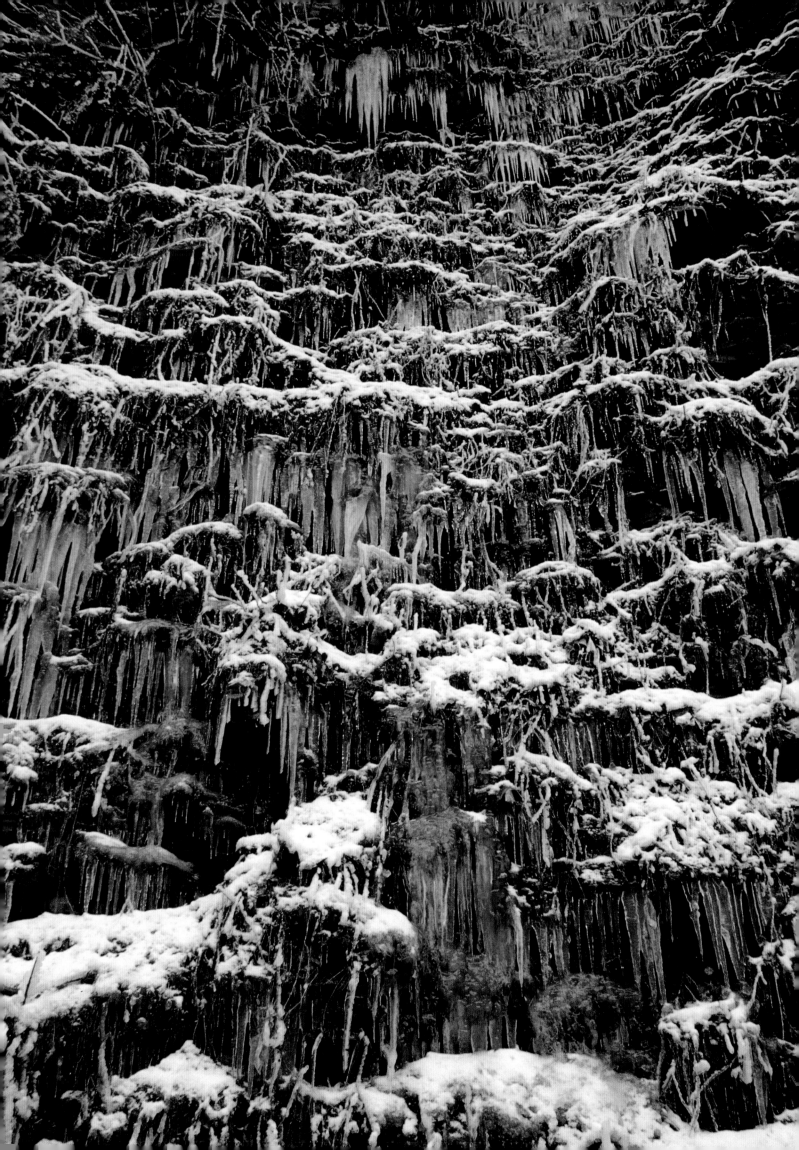

# CONKLIN GULLY

What do you see? Look closely.
In the foreground, large broken pieces of ice rest
on the bank where they were carried when a brief
warm spell melted snow into the creek, which
then rose to shatter its icy lid, dissolving some
sections and carrying others ashore. In the back-
ground, pyramids of snow on the left and right
sides indicate erosion funnels in the cliff where
water runs off it and accumulates piles of rocks
at its base. In the midground is the stream.
But what are the circles there, in the center
of the picture?

For weeks they puzzled me, until one night,
reading my journals, I came across an entry for
this gorge, written in the autumn. In this same
location, I described a whirlpool of leaves. The
leaves are gone; the whirlpool remains, frozen.

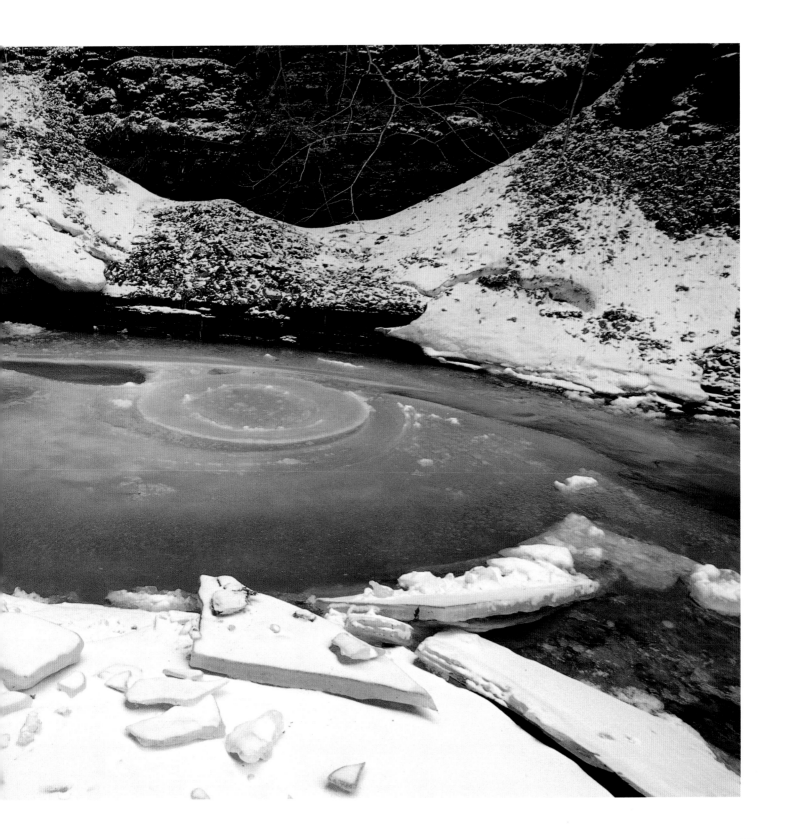

# CONKLIN GULLY

This is the lower third of a hundred-foot seasonal waterfall in a tributary feeding into Conklin Gully. It flows only in spring, spilling over a sheer cliff. By summer, it dries up, except during heavy downpours when it springs to life for a few hours. In winter, the trickles freeze and accumulate, building a wall of ice that attracts local climbers.

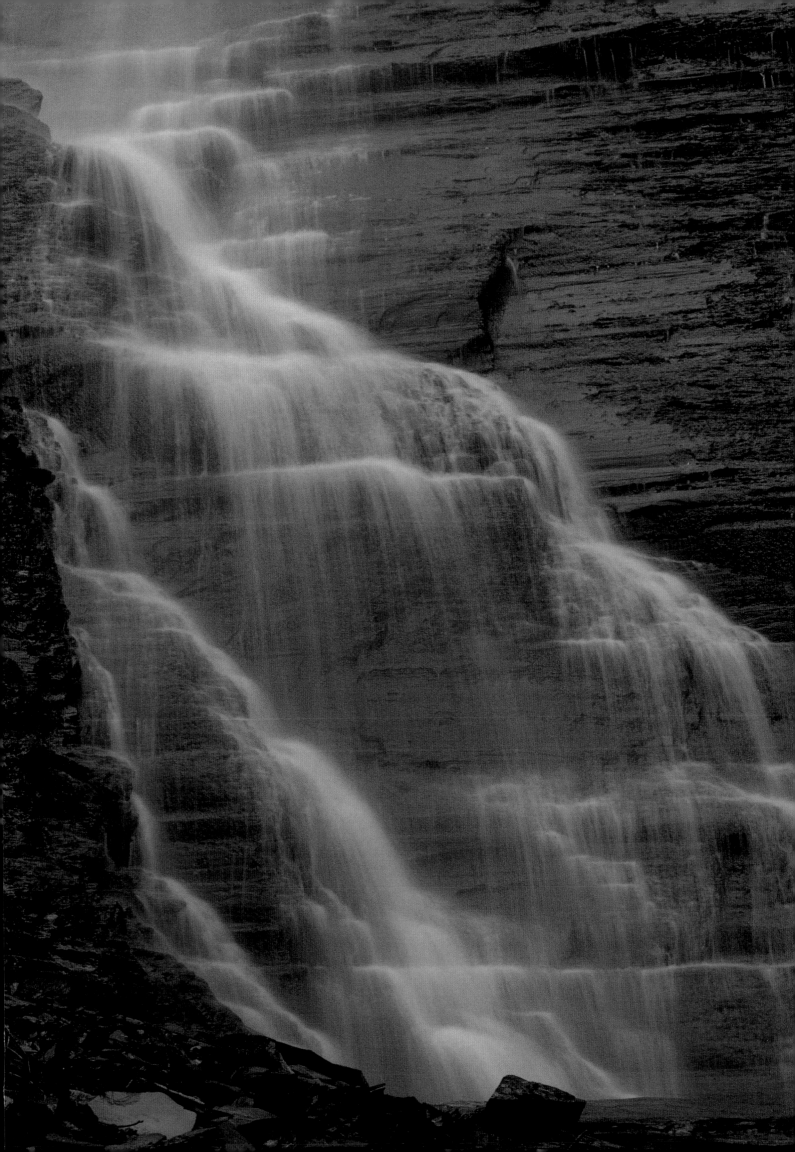

# EGGLESTON GLEN

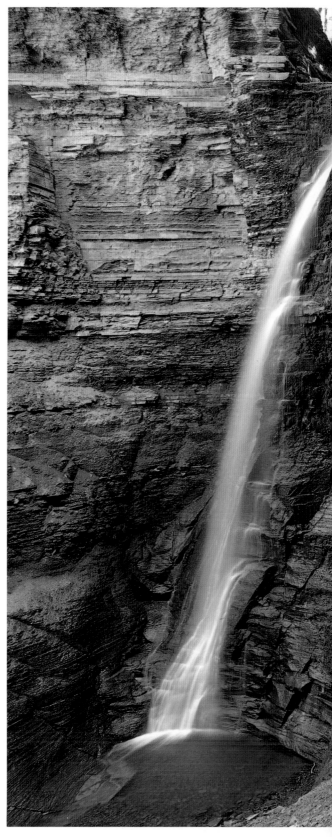

Were you to walk up the loose talus of this slope and feel it crunch underfoot, you couldn't help notice that these cliffs are rapidly eroding. And so they should. After all, they are little more than hardened mud and silt, deposited millions of years ago by an ancient river along an ancient seashore. And if you were to walk up the slope and stand at the base of the cliff, you'd be standing alongside millions of years of nature's work. Just as your hand spans decades of recorded time when you lay it across a freshly cut tree stump, so does your body when you lean against a gorge cliff. Only the time spanned multiplies a hundred thousand times. If the rock next to your ear is three hundred million years old, then that beside your toes is likely ten million years older.

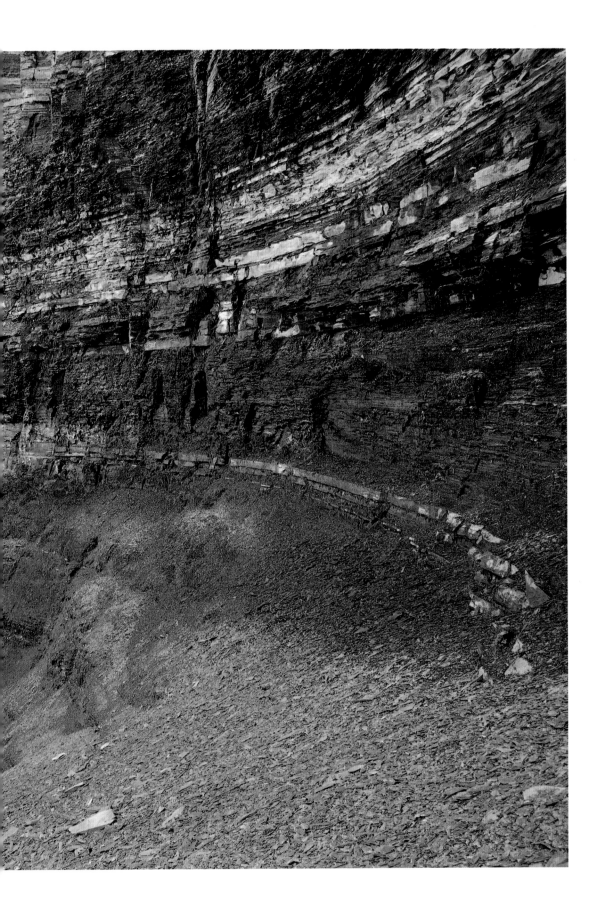

# REYNOLDS GULLY

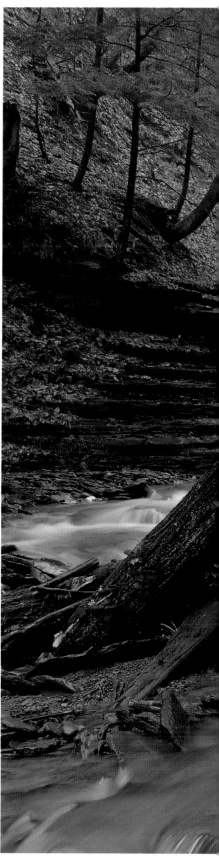

A gorge can have a distinct psychological effect on you. From an overlook at rim level, a gorge inspires. That's because you are literally above it all. Within a gorge, especially an undeveloped one, your reactions may surprise you. At first, its beauty and fragility intrigue you. You wonder at the fallen trees that continue to leaf out and marvel at the ferns quaking in the constant breeze. But the longer you're there, the more your reactions turn inward to the constant caution required for each step across the slippery creek bed, the incessant, all-encompassing chatter of the stream, the rock columns leaning out precariously overhead, cliff walls squeezing in, always-dimmed light growing darker as the afternoon slips away, knuckles scraped in a search for handholds. Too much time in the gorge takes its toll. You begin to hear voices mixed in with the stream noise; you worry about rocks falling on you; the wonder at nature is replaced with worry. Time to go home.

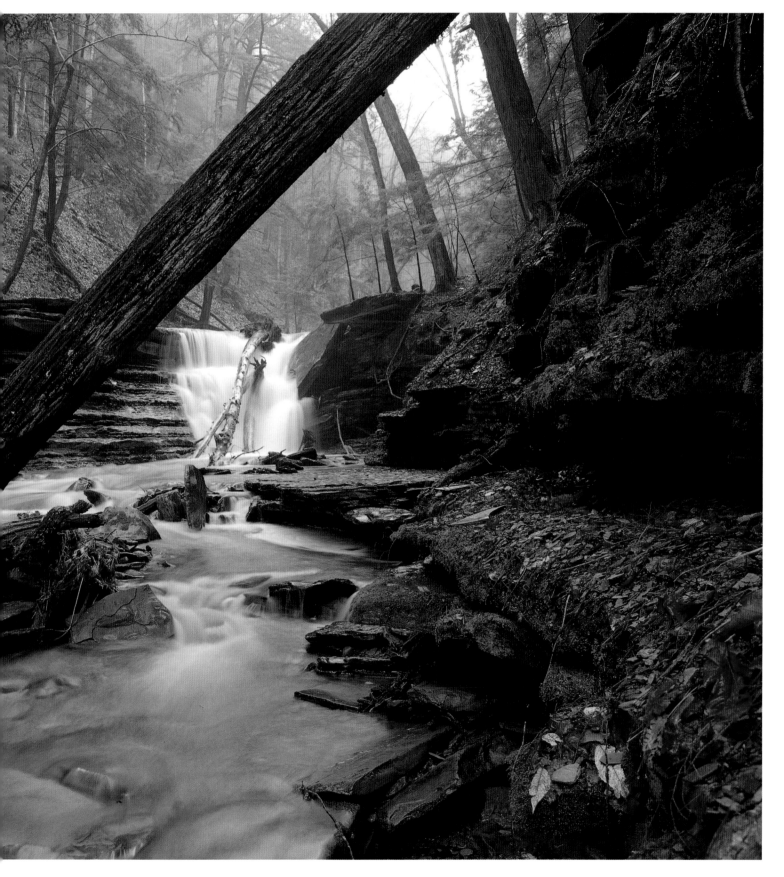

# DEEP RUN GULLY

In a gorge everything is moving, although at widely varying paces. The flow of water is readily visible, the decline of trees is not; piles of rocks and pebbles at cliff bases mark areas of ongoing erosion.

Although many of the streams tumble and fall down steep hillsides, some are placid, flowing

quietly along most of their course. In the still pools, minnows and water striders glide along the surface. Shy wood frogs kerplunk into the water and lay still on the bottom where their mottled camouflage-brown blends in perfectly with the silt, rocks and leaves.

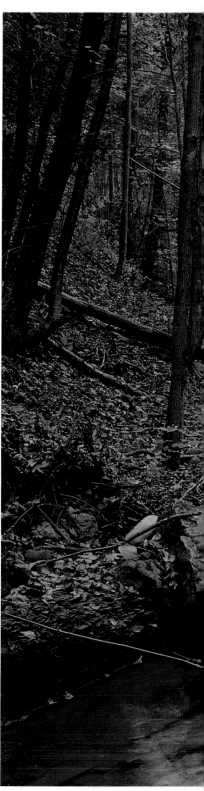

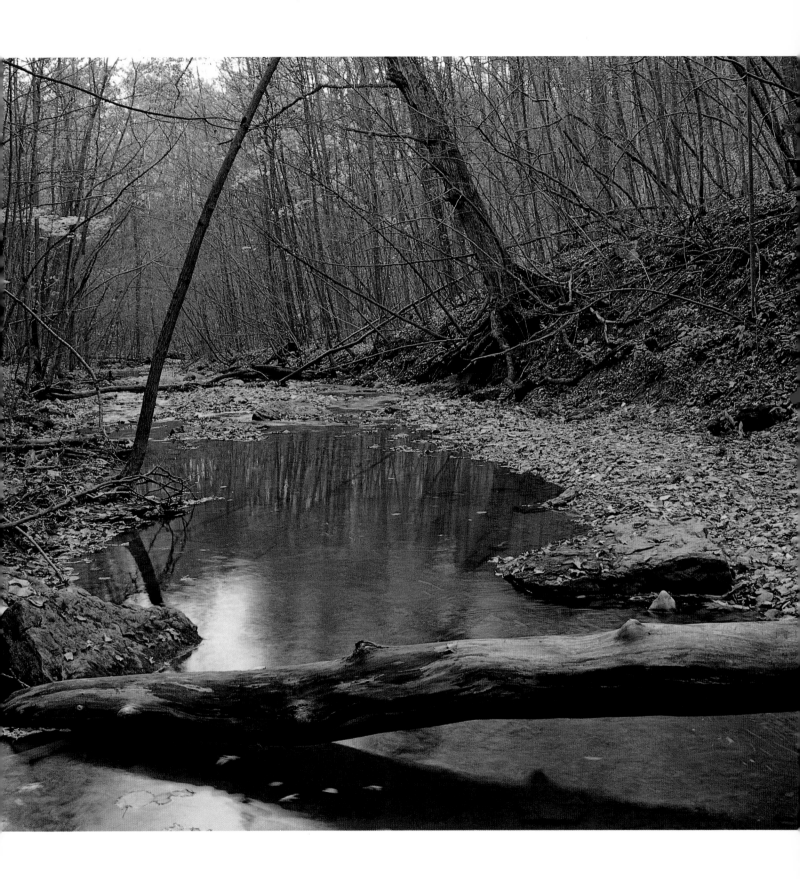

# MOONSHINE

Waterfalls have many aspects of appeal: beauty, as they hiss and twist, brushing their calligraphy over rugged rock faces; energy, as they offer inexpensive power to move the turbines that light our malls and spin our hard drives; wealth, as they attract tourists who pay hard cash to buy souvenirs and eat and sleep nearby. But their greatest appeal may derive from our most basic need—for water to survive. That feeling of inner connection springs to life as we see water animated, bubbling and boiling, sputtering,

coursing through every niche and crevice as it shatters in a tumble down a cliff only to re-form and heal as a stream. Just as each and every waterfall is unique, so is water itself. All matter responds, under an extreme range of conditions, to temperature variations by becoming solid, liquid or vapor. But water is highly unusual—and valuable to us—because it exists in all three states in the same narrow temperature range in which we thrive.

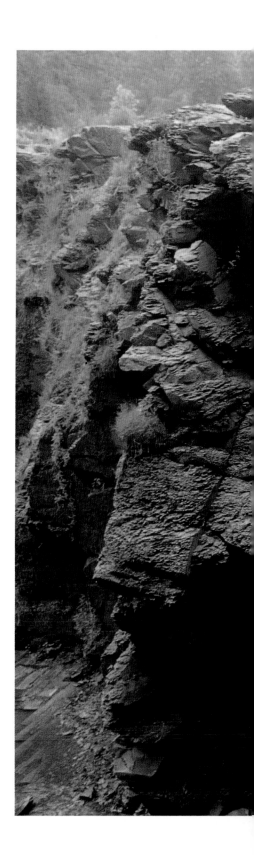

# FALLS

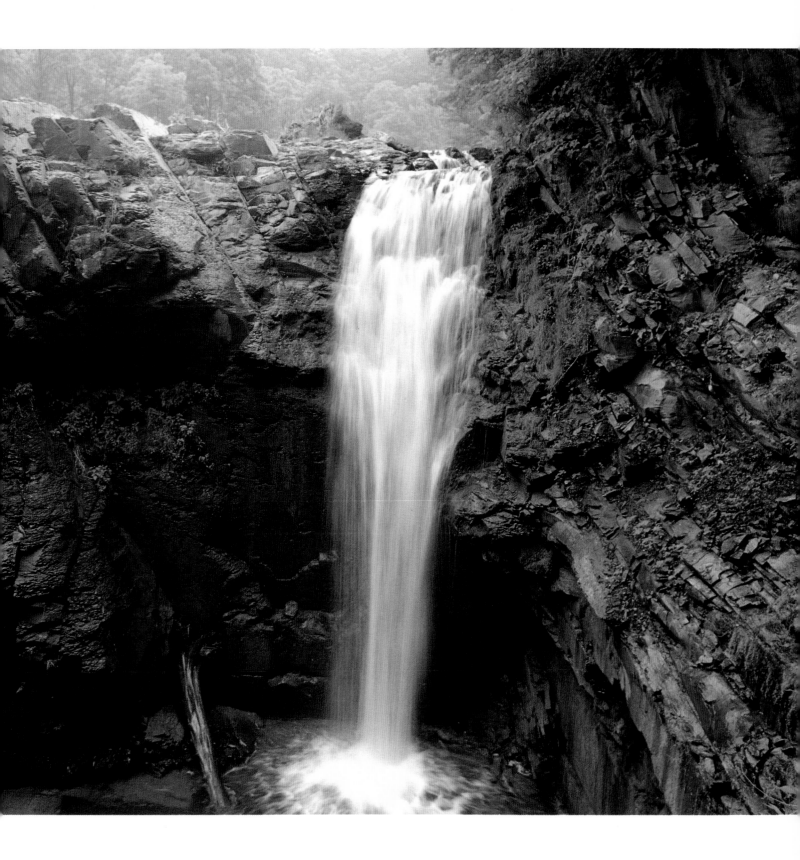

# BRIGGS GULLY

Ever present, ever exerting its irresistible power, the most effective and unyielding force in the gullies is invisible. It is unheard and unfelt. While waters rage and roar through the gullies each spring, and ice silently pries on the cliffs each winter, while intermittent snows push on tired trees and winds snatch at them, the silent force is ever at work. It never tires. It never gives up. It's there night and day, through every season. Always working, always pulling, it draws downward inexorably on everything in the gorge. Neither tree, nor rock, nor water can overcome or outwait gravity.

Gravity pulls water down from the clouds and then down the hills toward the seas; it pulls loosened rocks from the cliff, pulls undermined trees over in a great crash. In the gorge as on all the earth, gravity is the great mover, the ultimate force.

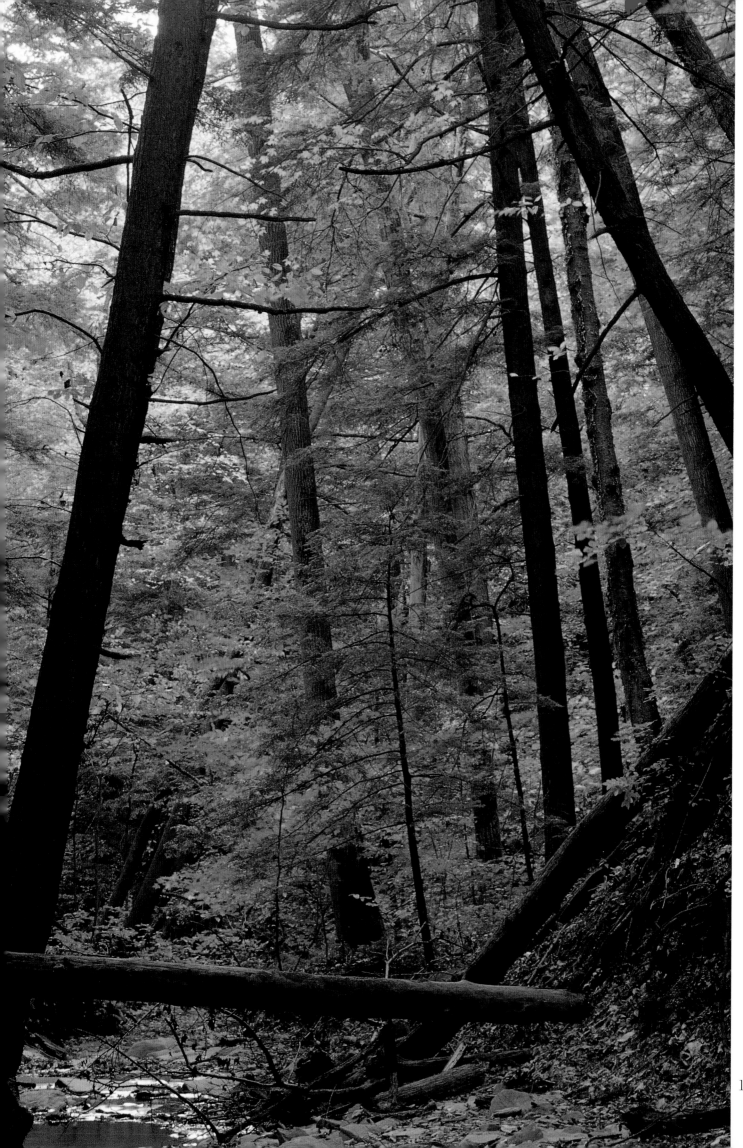

# WOLF CREEK

## LETCHWORTH STATE PARK

Acrobatic trees seem to defy gravity as they cling to the receding banks of Wolf Creek in Letchworth State Park. Such death-defying feats by trees that seemingly squeeze out every possible moment of existence are common in gorges—but not as common as the rotting, limbless boles. Wolf Creek splashes into the Genesee River as a sixty-foot waterfall.

It's visible from the Inspiration Point over-look and accessible during the gentle white-water raft trips which are run down the Genesee River from the old swimming pool area.

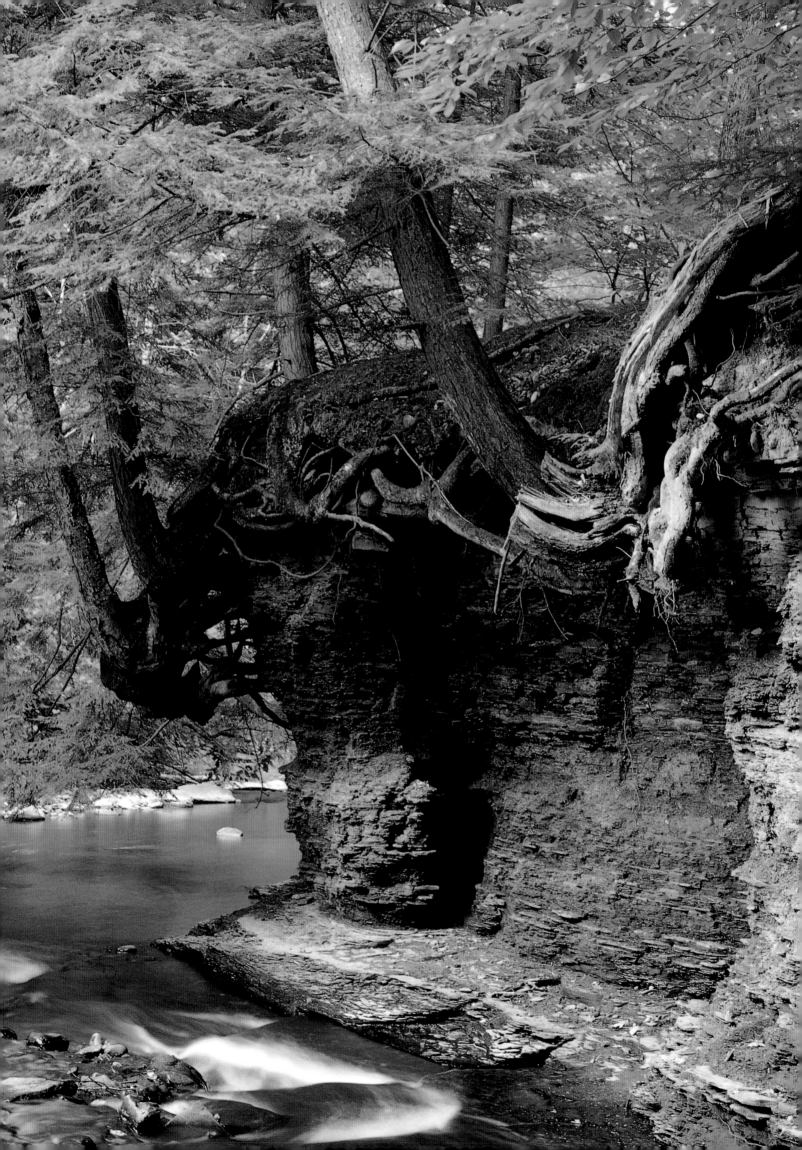

# TINKER FALLS

Just south of Syracuse near Tully, Tinker Falls is most lovely when the water level is high and a sheet of water spills over its brink of limestone.

The gorges present a paradox of age, both in themselves and in our perspective. They are fairly young. Most are less than ten thousand years old, yet they are formed of rocks hundreds of millions of years old. It's like building a brand new house with bricks from the eighteenth century.

In human artifacts—from Ming vases to arrowheads to a bentwood rocking chair, age, as well as beauty, is granted great respect and worth. Age in the land and its "artifacts" is largely ignored. The limestone holding up Tinker Falls is several hundred million years old, and the rock at the base is tens of millions of years older.

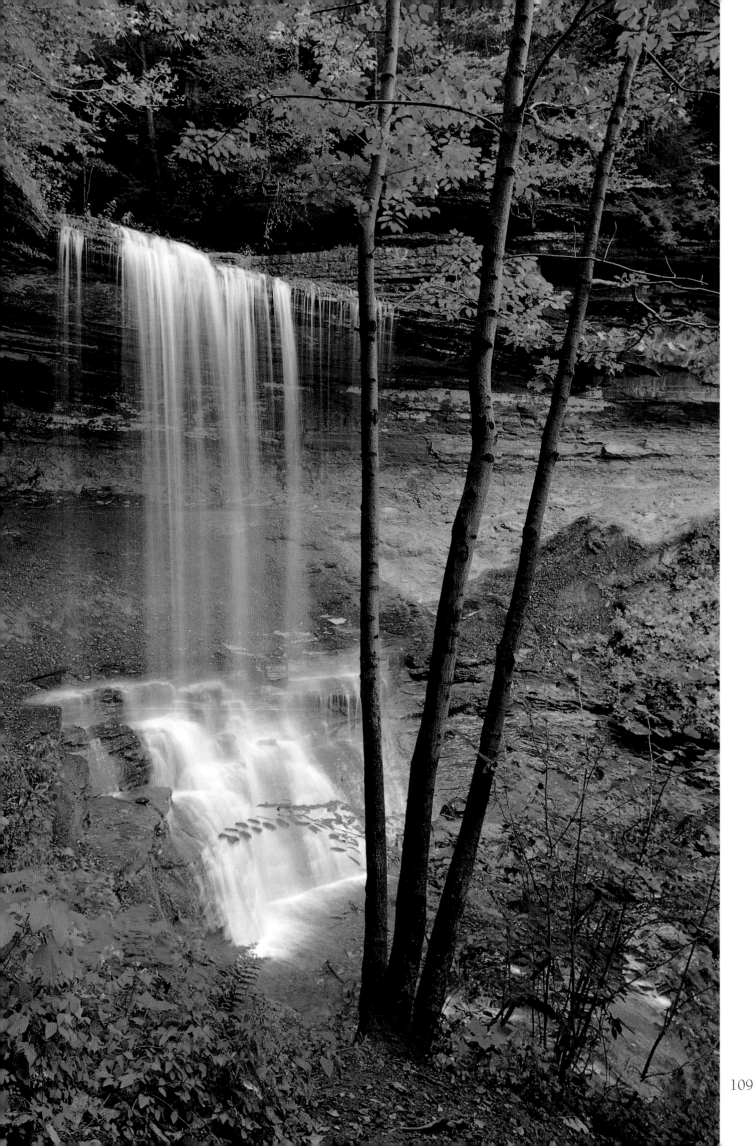

# LICK BROOK

Accessible by a trail from Town Line Road, Lick Brook gully contains two major waterfalls, the biggest shown here. In spring, this silver braid drops nearly eighty feet. In summer, it may dry up. In winter, it forms a column of ice that attracts local climbers.

Just as the buildup of ice in winter reduces a stream's volume of water, so did the buildup of glacial ice reduce the volume of water in its primary source—the oceans. At the height of the last glacier, so much water was turned into ice that the oceans were lowered some three hundred feet. The withdrawing waters uncovered a land bridge between Alaska and Asia, across which came many animals such as saber tooth tigers, giant sloths, and the first humans to inhabit North America.

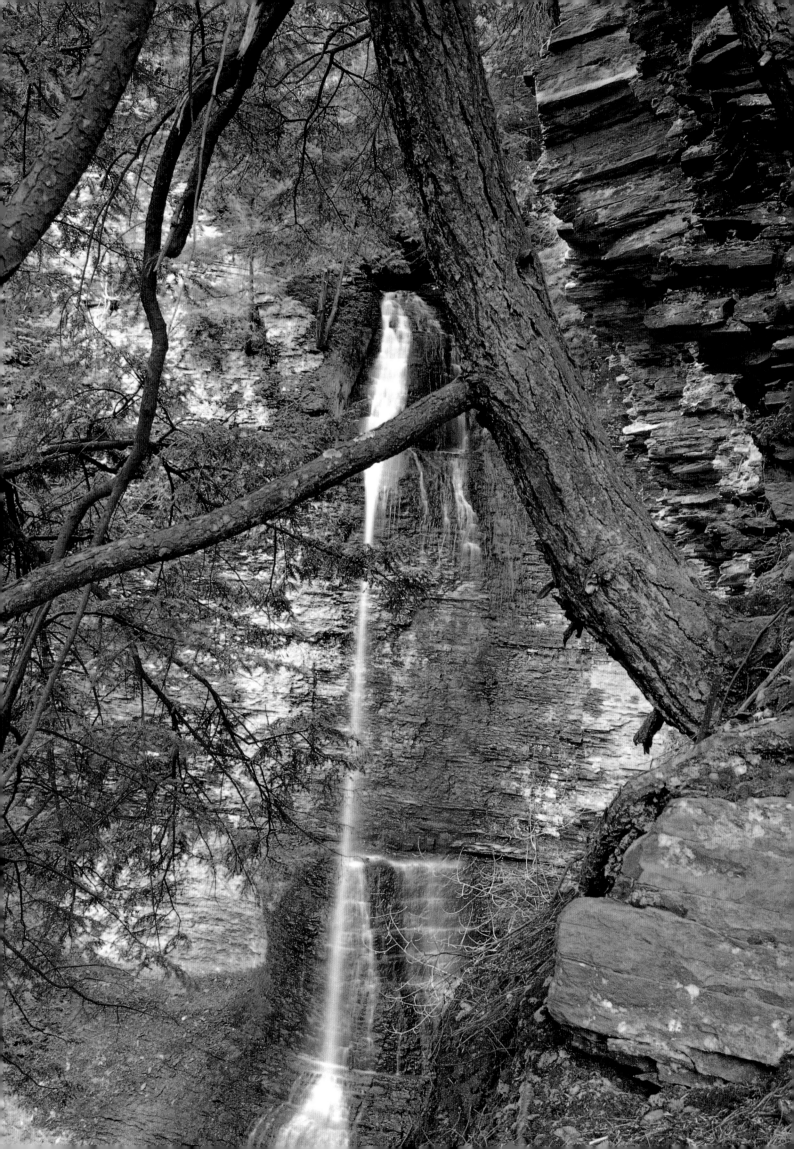

# BRAY GULLY

Where is this gorge? It could be anywhere in the Finger Lakes. It's one of the streams I found in the *New York State Atlas & Gazetteer* that was marked with narrowly spaced contour lines, meaning a stream surrounded by steep hills. I drove to it, walked up the channel and found this waterfall, which was surely known to most of its closest neighbors. In fact, one of them told me to look out for rattlesnakes during high waters

in summer. The locals like to instill adventure into their gorges.

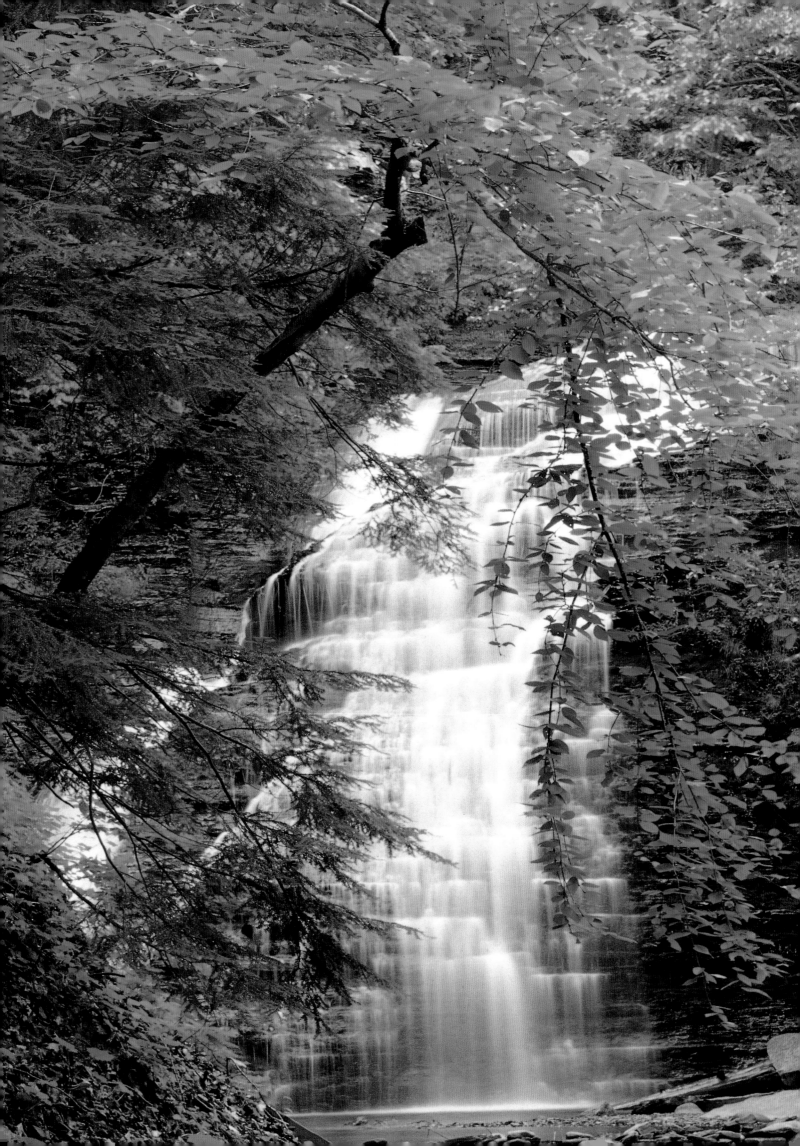

# GRIMES GLEN

How many waterfalls are there in the Finger Lakes? In part, the answer depends on when you count them. Count them in the spring, when water from melting snow trickles down every hillside gully, and they would number in the thousands. Seen from across a valley, these temporary cascades seem like strings tied out for morning glories. Up close, they are streams, one, two or three feet wide.

Scott Ensminger, who has been exploring and conducting a survey, has recorded four hundred twenty-five waterfalls in this region to date. Should you decide you'd like your own waterfall, keep an eye on the local real estate ads—several properties with waterfalls are offered annually.

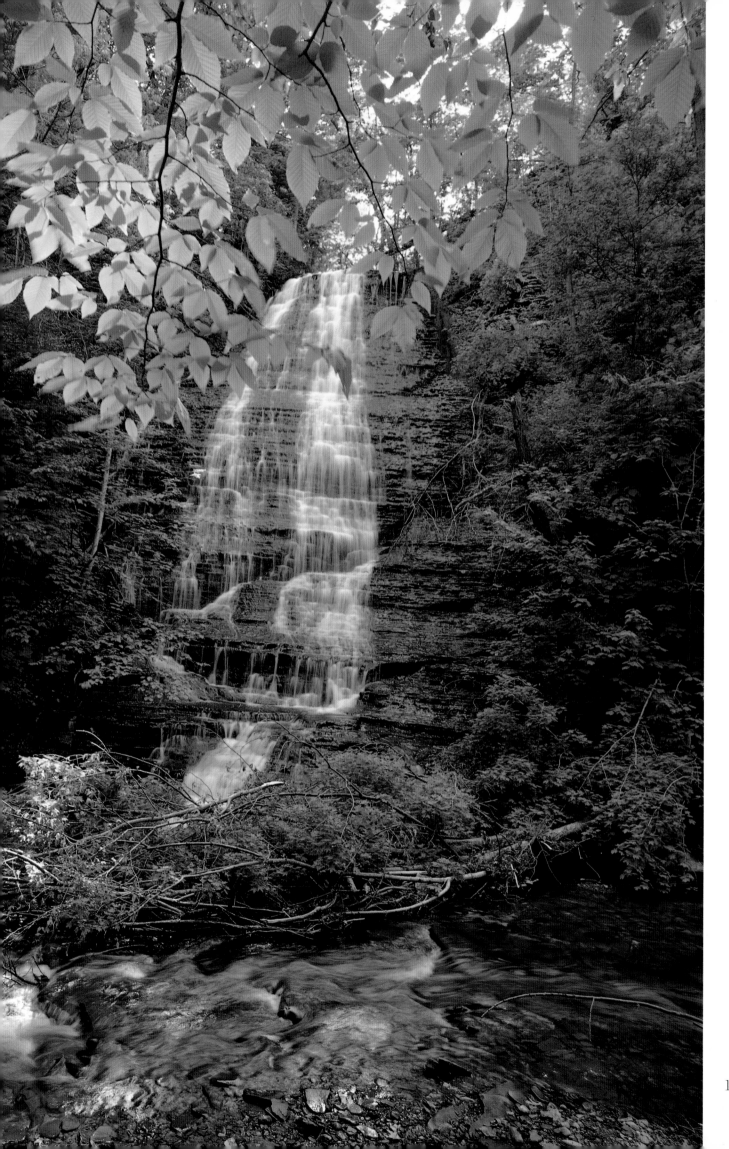

# CHEQUAGA FALLS

Almost cascading down upon the main street of the town of Montour Falls is Chequaga Falls. Like most of the waterfalls pictured in this book, it is white. Except during spring floods when the falls turn brownish with the load of rock particles they are carrying, they invariably appear white. Why? Above and below a falls, the stream may be clear or slightly colored, but never white.

Waterfalls appear white for two reasons. The main reason is that as the water tumbles through space, it breaks into thousands of droplets, each picking up molecules of air. It is the extra air in the water that whitens waterfalls, like aeration in a faucet. This whiteness is then emphasized by the slow shutter speeds used to make many waterfall photos.

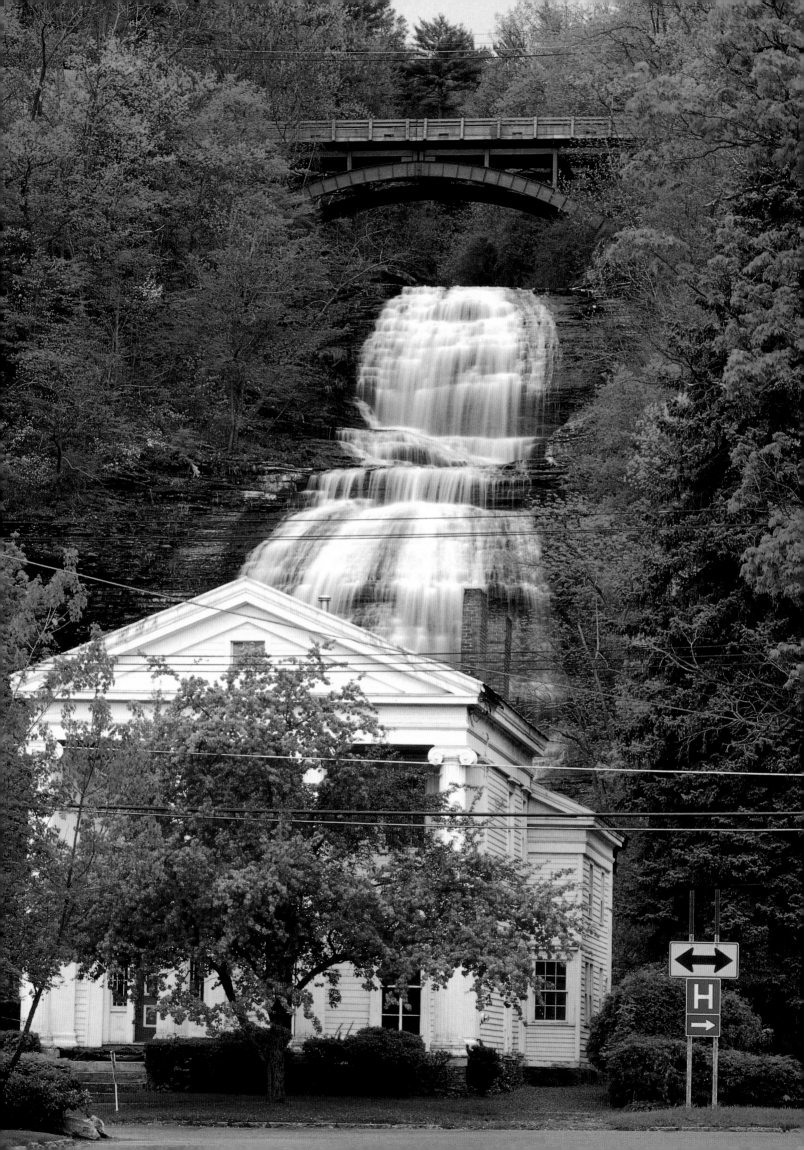

# PHOTOGRAPHING THE FALLS

ALTHOUGH a certain level of technical and artistic mastery helps in landscape photography, the most important technique may well be the least considered—perseverance and planning.

A good outdoor photograph frequently results from many variables all falling into place. Some of those variables are within your control, so planning for them is important. You can plan on carrying the right equipment and film, on going in a certain season, sometimes even in certain weather.

But unless you're intimately familiar with an area, you can't plan on finding just the right angle at that location or knowing just when the leaves will begin to bud. Unless you're omniscient, you can't count on being at the waterfall on one of the three days in autumn when the setting sun aligns with the narrow angle of the gorge and inflames the falling water with its rich orange light, or when the bright midday sun bounces off a glowing maple on the rim to reflect in a puddle, or when unusually large snowflakes drift from the sky and contrast starkly with the dark cliffs. You can't predict when a cluster of columbines will dangle picturesquely from a cliff, or when a newly fallen tree will span the gorge to frame a distant waterfall, or when two teenagers will come round a bend on a hot summer day and frolic in the falls.

Since you can control only a few of the many variables in landscape photography, perseverance is crucial. Being there. You have to be there often enough to bring the odds to your side. For this five-year project, I made nearly a hundred trips into the Finger Lakes region (I quit keeping track late in the game), and put over 10,000 miles on my car. The average

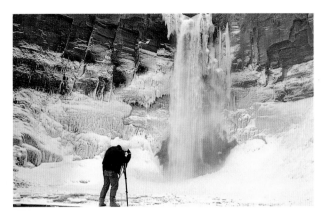

trip was about eight hours.

## I was obsessed

My obsession let me enjoy wet feet, cold hands, slides down steep slopes, one tumble over a small waterfall, and at least one futile overnight stay at the base of a waterfall as I tried to create a photo of star trails rotating around its crest. (It didn't work. The bright scratches of star trails came out but the falls stayed invisible in the darkness.)

My obsession drove me to travel in all weather, forced me to visit most of the places in at least three separate seasons—and often three times in each season to see how the changes progressed and water levels fluctuated. Even after all that, I don't think I made enough trips.

My obsession roused me at night when rain pattered on the roof and left me wondering what the falls at Great Gully would look like the next day. Was the rain heavy enough there (some 70 miles distant) to send the stream gushing over the falls, and if it was, should I skip work to go see them? I usually did.

My obsession wasn't overwhelming. The great landscape photographers (and probably those successful in anything) followed the demands of an obsession far greater than mine. Anecdotes abound of Ansel Adams waiting days on end in one location for the right light. Technical and artistic skills are important. But they can't make up for being there.

## How I photographed the gorges

All the color photographs in this book were taken on these Kodak transparency films: Kodachrome, Ektachrome 100 plus, and Ektachrome Elite. Transparency (or slide) films are best suited for slide

shows and book publishing. For prints, I regularly used Kodak T-Max 100 black-and-white film and Kodak Ektar film (now called Royal Gold). All of the above films have an ISO speed of 100 or lower. These slow-speed films give exceptional quality.

My camera bag held both 35mm and medium-format single lens reflex (SLR) cameras. I almost always mounted my camera on a tripod. In the summer I coated myself with mosquito repellent, which gave me enough relief to actually take pictures. My bag weighed about 20 pounds and hung freely from my shoulder, often tending to pull me from precarious perches as I edged along a shale ledge. It wasn't a stable arrangement but I favored convenience over stability.

A medium-format camera uses bigger film than a 35mm camera. That means better technical quality, finer grain and a sharper image, because the negative doesn't have to be enlarged as much to make a print. Ansel Adams often used 4 × 5 inch and 8 × 10 inch sheet film to get his superb photos.

Since most people probably use a 35mm camera, I'll talk mainly about how I used mine. Most often (for about three-quarters of the photographs), I used a 24mm wide-angle lens. I used it so often because narrow, winding gorges don't give you much room to step back or to the side to take in the whole scene. Since the waterfalls were often illuminated only by the bluish light of the sky, I often used a light yellow No. 81 filter to offset that and make the colors seem natural. I also regularly used a polarizing filter which reduces reflections from both water and the surfaces of objects and makes colors seem more saturated.

A tripod was essential because of slow shutter speeds. Without it, most of the pictures would have been blurred. I used slow shutter speeds for three reasons. First, it's often so dim in a gorge that slow shutter speeds are required to get enough light onto the film and expose it correctly; I often used one-second shutter speeds and speeds over ten seconds were not uncommon. Second, I also usually wanted to use a slow speed for its effects. Slow shutter speeds give falling water that soft cotton-candy look. Fast shutter

speeds (shorter than 1/60th of a second) reveal individual droplets and rivulets within the tumbling falls. Sometimes those are attractive results, but more often they're not. Third, because I wanted most of my pictures to be completely in focus from the foreground to the background, I had to use a small lens aperture —usually f/16 or f/22. Since these let in little light, again, a slow shutter speed was needed to expose the film correctly.

Almost as important as the subject, sometimes more so, is the light. Light greatly influences appearance. Theater-goers see that every time they attend a new play. Within a gorge, I didn't have much choice about the type of light that would be there, since the sun only flooded into the larger gorges. The light illuminating most gorges is indirect, diffuse; it's light from the sky. And that's okay, because diffuse light often flatters subjects.

Diffuse light is also shadowless. It shows everything equally well. Since I wanted to show nearly everything in my pictures, diffuse light was perfect. But occasionally a shaft of sunlight sneaked through an opening, and I took full advantage of the energy and excitement it added to the scene.

What I did in taking pictures may not be the best way for you. So here's how you can get good pictures without carrying very much stuff.

## The simple way

If you take pictures casually, then taking pictures in most gorges will be easy. The most important thing you should do is use a high-speed/fast film. An ISO 400-speed film will do nicely. Most films include the film speed prominently in their names. Thus, Kodak Gold 400 film is a 400-speed film. A high-speed film will let you take pictures in all but the dimmest of gorges without using a tripod. And if you're like most people, you will prefer a color print (negative) film over slide film or black-and-white film.

If you have a simple camera, you're in luck. Most simple cameras use a moderate wide-angle lens that will capture scenes in sharp focus from front to back and include a wide area.

If you have a single-lens reflex camera, you have the option of using different lenses. Should you have one, be sure to bring along a wide-angle lens so you can take in a wider area. Photographing in a gorge is a bit like trying to take pictures in your bathroom. You're in a confined area and it's difficult to step back far enough to include the whole room. A 24 or 28mm wide-angle lens will help greatly (a 35mm wide-angle lens is acceptable but won't always cover a wide enough area). A zoom lens that goes down to the wide-angle range will also work well.

## A more advanced approach

A tripod—that's what you'll need most. If you're like most landscape photographers, you'll be using very small apertures, f/16 or f/22, to achieve front-to-back sharpness in your photos. In dim light, small apertures need slow shutter speeds to achieve correct exposure. At slow shutter speeds, only a tripod will give the stability needed to avoid blurry pictures. Carry lenses that cover focal lengths from 24mm to 135mm. You won't often need a long telephoto lens. If you have a macro lens, take it. You'll find many unusual ferns and other plants to photograph as well as striking water patterns.

Use the film you normally use. I use low- and medium-speed films for their good sharpness and fine grain. When shooting slide film in the gorge, I prefer E-6 films over Kodachrome. I like their rendering of greens and blues. My slide film of choice is Kodak Elite 100 film. It's sharper and finer-grained than Kodachrome 64 film. If you shoot slide film, take along an 81A or 81B warming filter to compensate for the indirect bluish light that comes from the sky; a skylight filter won't provide enough coloration to make a noticeable difference.

## Keep your eyes open

As you walk along, look both near and far. Consider the whole of the gorge and if you favor what you see, look for a foreground element to add

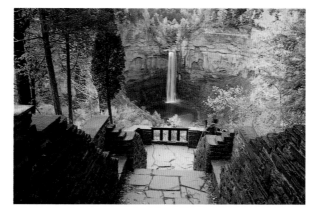

interest and depth to the photo—a large rock, ferns on a bank, a water-worn log.

Although your progress is forward, turn often and look back. You may have just walked by something, but you saw it only when you were moving forward. When you turn around and look, the foreground and background relationship of the terrain is reversed. Things will look very different, sometimes much better. And although you'll see this view on your way back, two things will have changed by then: first, the lighting will be different, and that's good because it will alter the appearance of the scene, perhaps for the better; second, your mood will have changed. You will be returning and, for most of us, that signals the end of the trip, that you are tired and eager to get back, not to take more pictures.

Vary your viewpoint. Although it's natural to take pictures while standing, that viewpoint may eventually seem both repetitive and boring. Stoop to ground level and show the water rushing toward the camera, or scramble up the side of a slope so you are looking head-on at a waterfall instead of always looking up at it. Many trails deliver you to roughly the same location—directly facing the waterfall. Look for trails that take you to the side so you can get a different angle.

Vary your composition. Although it's natural to show a whole waterfall in the center of a picture, such composition may also eventually seem boring. Occasionally, show just a fragment of a waterfall, its lower half, or show it partially blocked by trees as if you are viewing it from the woods. Try showing it small, as just a part of a bigger landscape, or moving it to the far side of the picture.

Vary your subject selection. There's more to the gorges than waterfalls. Look for trees tilting precariously from the cliffs or logs spanning the creeks. Look for the texture water forms as it funnels between two rocks or thins over the shallows. Look for the mounds of shale accumulating at the base of cliffs and displays of ferns waving their fronds.

# THE FINGER LAKES REGION

ON THE following pages are descriptions of ten of my favorite gorges in the Finger Lakes region of Central New York. Of course, the selection is wholly subjective, based on my own likes. The accompanying map shows not only where they are but also the locations of many other gorges. Some of the small towns at the southern ends of the lakes are surrounded by several gorges and waterfalls that could be seen in one trip.

If you decide to visit in summer, take a towel, dry clothes and dry shoes. On purpose or by accident, you are likely to get wet (several of the state parks have swimming areas). By mid-July, unless it's been rainy, many of the falls dwindle significantly. Gorge trails in many of the state parks are open only from mid-May to late October, when there's no risk of tumbles due to ice. Most of the state parks charge a small admission fee in season. If you plan to hike a gorge, above all, be careful. The trails can be slippery, and rocks can fall from the cliffs at any time.

## Map Key

1 Bray Gully, Honeoye Lake

2 Briggs Gully, Honeoye Lake

3 Buttermilk Falls State Park, Ithaca

4 Carpenter Falls, west side of Skaneateales Lake

5 Cascadilla Gorge, Ithaca

6 Chequaga Falls, Montour Falls

7 Chittenango Falls, south of Chittenango village

8 Clark's Gully (High Tor), north of Naples

*9 Conklin Gully, Naples*

10 Deep Run Gully, east side of Canandaigua Lake

11 Eggleston Glen, east side of Keuka Lake

*12 Fillmore Glen State Park, Moravia*

13 Frontenac Gorge, Trumansburg

14 Upper and Lower Falls, Genesee River, Rochester

15 Great Gully, east side of Cayuga Lake

*16 Grimes Glen, Naples*

17 Hammondsport Gorge, west side of Hammondsport village

*18 Havana Glen, Montour Falls*

19 Ithaca Falls, Ithaca

20 Keuka Outlet, Dresden/ Penn Yan

*21 Letchworth State Park, Mt. Morris, Middle Falls, Wolf Creek*

22 Lick Brook, Ithaca

23 Moonshine Falls, east side of Cayuga Lake

*24 Reynolds Gully, Hemlock Lake*

25 Salmon Creek, Ludlowville

*26 Stony Brook State Park, Dansville*

27 Tannery Creek Falls, Naples

*28 Taughannock Falls State Park, Trumansburg*

29 Tinker Falls, Tully

*30 Robert H. Treman State Park, Ithaca*

*31 Watkins Glen State Park, Watkins Glen*

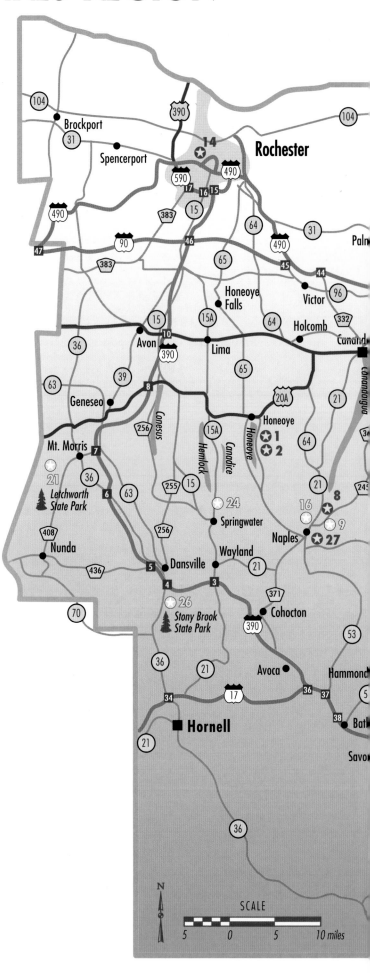

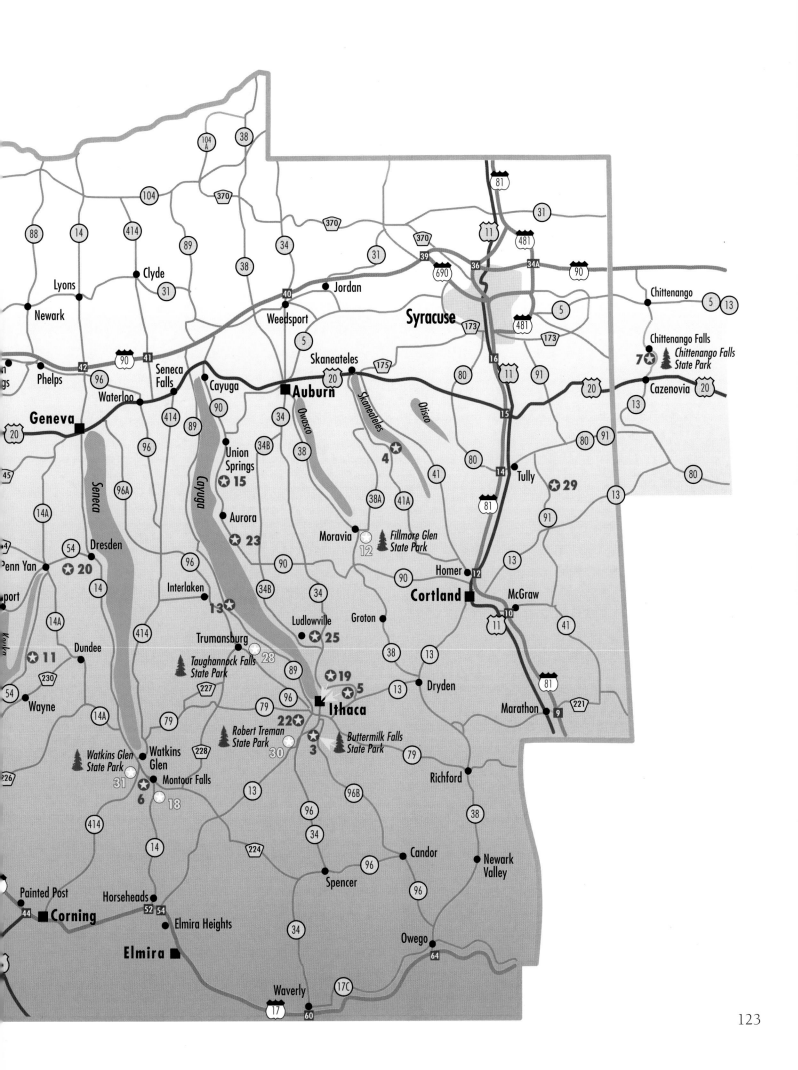

Lyons
Clyde
Newark
Phelps
Geneva
Waterloo
Seneca Falls
Cayuga
Auburn
Skaneateles
Weedsport
Jordan
Syracuse
Chittenango
Chittenango Falls
Chittenango Falls State Park
Cazenovia
Penn Yan
Dresden
Seneca
Cayuga
Union Springs
Aurora
Moravia
Fillmore Glen State Park
Tully
Homer
Cortland
McGraw
Interlaken
Dundee
Ludlowville
Groton
Dryden
Marathon
Trumansburg
Taughannock Falls State Park
Ithaca
Robert Treman State Park
Buttermilk Falls State Park
Richford
Watkins Glen State Park
Watkins Glen
Montour Falls
Candor
Newark Valley
Spencer
Painted Post
Corning
Horseheads
Elmira Heights
Elmira
Owego
Waverly
Wayne
Owasco
Skaneateles
Otisco

123

# TEN GORGES TO VISIT

*Numbers correspond to map*

## Conklin Gully, Naples **9**

**HIKE DIFFICULTY:** Difficult; no developed trail in gorge. Often, you must walk in water, and negotiate numerous tree falls and waterfalls. Hike within the gorge at your own risk, and don't do it alone.

**ACCESSIBILITY:** Easy; entrance to gorge 30 feet from road.

**DIRECTIONS:** At northern end of Naples, turn onto Route 245 opposite Bob 'n Ruth's, go about two miles and turn right onto Parrish Road. About 150 feet after you turn, you'll see a small parking area (really just a widened road shoulder) on the right, opposite a barn. The entrance to the gorge is 50 feet into the woods and immediately crosses a stream. Another trail to the left goes along the rim.

**HIKING TIME:** One and one-half hours round trip to the base of major falls; about one mile from road.

**HIGHLIGHTS:** Several small falls, numerous fallen trees to test your agility, and three larger falls.

## Fillmore Glen State Park, Moravia **12**

**HIKE DIFFICULTY:** Easy to moderate. The lower falls is only a short walk, on level ground, from the parking lot. The upper falls is about two miles uphill (from the lower parking lot) on a good trail (or about a quarter mile downhill from the upper turnaround).

**ACCESSIBILITY:** Easy. Good trails.

**DIRECTIONS:** One mile south of the village of Moravia. From NYS Thruway, get off at exit 43 and go to Auburn. Take Route 38 south a mile past Moravia to the park entrance. From Ithaca, head north on Route 34. At the intersection with State Route 90, turn right (east) and follow 90 until it runs into Route 38. Turn left (north) onto Route 38; follow it for four or five miles until you come to the park entrance.

**HIKING TIME:** Five minutes to lower falls from the lower parking lot. Upper falls is perhaps an hour and a half from that lot, or about ten minutes from automobile access.

**HIGHLIGHTS:** Two major waterfalls and many smaller ones. Camping and swimming areas.

## Grimes Glen, Naples **16**

**HIKE DIFFICULTY:** Moderate. There's an intermittent trail interrupted by cliffs that give you the chance to walk in the water.

**ACCESSIBILITY:** Easy. A parking lot is right beside the stream.

**DIRECTIONS:** As you head south through the center of Naples, you'll notice a clapboard building (blue, and housing a bookstore, as this was written) on the right, and a small sign indicating Grimes Glen. Follow the road back for about half a mile to a parking area beside the stream.

**HIKING TIME:** One hour round trip to main falls.

**HIGHLIGHTS:** Lovely tributary falls about a third of a mile upstream. Another quarter mile upstream is a 60-foot falls with a plunge pool deep enough for swimming. Cliffs in this area are adorned with ferns and columbine.

---

*A number of the sites pictured in this book are on private property.*
*Please inquire before visiting and respect the rights and wishes of property owners.*

## Havana Glen, Montour Falls **18**

**HIKE DIFFICULTY:** Easy and short, with some steep wooden stairs (about 50 steps) with handrails.

**ACCESSIBILITY:** Easy; trail starts 50 feet from the parking lot.

**DIRECTIONS:** Lies three miles south of Watkins Glen off Route 14. A half mile south of the town of Montour Falls, turn east onto Havana Glen Road and, as the road starts up the hill, turn right and drive into the small town park. In summer you'll be charged $1 to park (camping available). A path at the back of the park leads a hundred yards to the falls.

**HIKING TIME:** Five minutes.

**HIGHLIGHTS:** This is the easiest falls to visit, and it is very picturesque. It gives you a good feel for the nature of shale cliffs and how a stream can eat through them. Eagle Cliff Falls spills 30 feet into a small amphitheater. You are allowed to stand under the falls.

## Letchworth State Park, Mt. Morris **21**

**HIKE DIFFICULTY:** Moderate for Lower Falls; easy for Middle and Upper Falls.

**ACCESSIBILITY:** Easy, via trails or immediate access from paved parking lots.

**DIRECTIONS:** This is a 17-mile gorge and state park with entrances at Castile, Mt. Morris, Perry and Portageville. Using Interstate 390, take the Mt. Morris exit. In Mt. Morris, head north on Route 36 for about two miles, and turn left to park entrance.

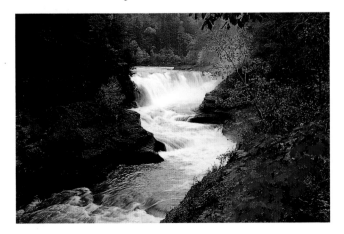

**HIKING TIME:** Lower Falls: forty minutes round trip; Middle Falls is adjacent to parking lot; Upper Falls is only a hundred yards from parking lot.

**HIGHLIGHTS:** Numerous vistas of this great gorge, whose depth exceeds 600 feet in some places, are offered at roadside pull-overs. The Inspiration Point pull-over gives a distant head-on view of the dramatic Middle Falls. Hiking trails abound as do waterfalls whose numbers grow during spring melt-off.

## Reynolds Gully (Hemlock Falls), Hemlock **24**

**HIKE DIFFICULTY:** Difficult, no developed trail. Much of walk is in the stream, often negotiating small waterfalls and tree falls.

**ACCESSIBILITY:** Easy, with entrance to gorge next to parking area. Visitors' hiking permit from city of Rochester required, as this is part of the watershed for Rochester's drinking water. Permit available from self-serve kiosk at north end of Hemlock Lake, or send SASE to Hemlock Filtration Plant, Hemlock, NY 14466. For more information, call 716-346-2617.

**DIRECTIONS:** Take Route 15A to an unimproved parking area about 1.5 miles north of Springwater. The parking area is on the east side of the highway, where the highway levels out at the bottom of a large hill.

**HIKING TIME:** One and one-half hours round trip to base of major falls.

**HIGHLIGHTS:** Several minor falls and, at end of hike, a 70-foot falls with a large shelf where you can sit and enjoy the cascading waters.

## Stony Brook State Park, Dansville **26**

**HIKE DIFFICULTY:** Moderate, on well-developed trails within and around gorge.

**ACCESSIBILITY:** Easy; trails start from paved parking lot.

**DIRECTIONS:** Entrance to park is on east side of Route 36, a few miles south of Dansville. Dansville can be reached from exits on Interstate 390.

**HIKING TIME:** One and one-half hours round trip via gorge trail; rim trails also available.

**HIGHLIGHTS:** Three major waterfalls and numerous smaller ones. Lovely stone bridges, walls and paths built by Works Progress Administration employees during the Great Depression. Great falls for splashing in. Upper falls can be reached only by leaving trail and walking in stream.

### Taughannock Falls State Park, Trumansburg  28

**HIKE DIFFICULTY:** Easy on gorge-floor trail; moderate on rim trail.

**ACCESSIBILITY:** Easy, wide, level trails in gorge, steeper trail along rim.

**DIRECTIONS:** Route 89, eight miles north of Ithaca.

**HIKING TIME:** Forty minutes round trip from parking lot on Route 89 to falls.

**HIGHLIGHTS:** At 214 feet, this is the highest continuous falls in New York, and its cliffs are another hundred feet higher. It has carved out a large amphitheater. From a former railroad (now pedestrian) bridge upstream, you can see another large falls. This is one of the few gorges open in the winter. The streambed is limestone; pitted by chemical action, it resembles a squashed waffle.

### Robert H. Treman State Park, Ithaca  29

**HIKE DIFFICULTY:** Moderate, but steep trails can leave the less well-conditioned winded.

**ACCESSIBILITY:** Easy from parking lots at upper and lower ends.

**DIRECTIONS:** Look for turn-off from Route 13 about three miles south of Ithaca. The gorge trail is a circuit; you can park at the top and walk down, then up, or vice versa starting from the bottom.

**HIKING TIME:** Two hours round trip through the gorge.

**HIGHLIGHTS:** Major waterfalls at both upper and lower sections of park. Trail at upper end more picturesque, as it goes down middle of the gorge. The Lower Falls spills into a big swimming hole, equipped with bathhouse, lifeguards and concession stand.

### Watkins Glen State Park, Watkins Glen  31

**HIKE DIFFICULTY:** Moderate, with several steep stone stairways.

**ACCESSIBILITY:** Easy from paved parking lot. For a small fee, shuttles will return you to upper or lower parking lot from either end of trail.

**DIRECTIONS:** Lower entrance on Route 14 in center of the town of Watkins Glen.

**HIKING TIME:** Two to three hours round trip.

**HIGHLIGHTS:** The oldest and most heavily visited of the state parks with gorges, its main feature is a deep, narrow, winding gorge with stone walls, trails and bridges. It's been tamed, but it's still a steep climb if you start at the bottom. Unlike many of the other gorges, this one has no large waterfalls within the park; it does, however, have several small falls and numerous cascades twisting through the rock. The trail is almost always wet and, in many places, water drips from the cliffs onto the trail (and you).

# SUGGESTED READING

Isachsen, Y.W. et al. (1991). *Geology of New York: A Simplified Account.* Albany: New York State Museum Geological Survey, State Education Department. University of New York Educational Leaflet No. 28. 284 pages.

Raymo, C. and M. E. Raymo (1989). *Written in Stone: A Geological History of the Northeastern United States.* Chester, Connecticut: The Globe Pequot Press. 164 pages.

Van Andel, T.H. (1985). *New Views of an Old Planet. Continental Drift and the History of the Earth.* Cambridge, England: Cambridge University Press. 324 pages.

Van Diver, B. (1985). *Roadside Geology of New York.* Missoula, Montana: Mountain Press Publishing Company. 411 pages.

Von Engeln, O.D. (1961). *The Finger Lakes Region, Its Origin and Nature.* Ithaca and London: Cornell University Press. 156 pages.

# ABOUT THE AUTHOR

DEREK DOEFFINGER works for Kodak, at its Rochester headquarters, where he has written photography books and now helps market digital cameras. His wife, daughter and their two dogs sometimes accompany him on his waterfall outings. When he's not sloshing up a creek, he's huffing and puffing as he tries to keep up with his daughter while they jog on the Erie Canal towpath.

# INDEX OF PHOTOGRAPHS